Pierre et Gilles

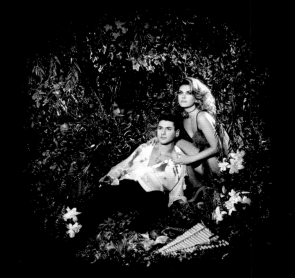

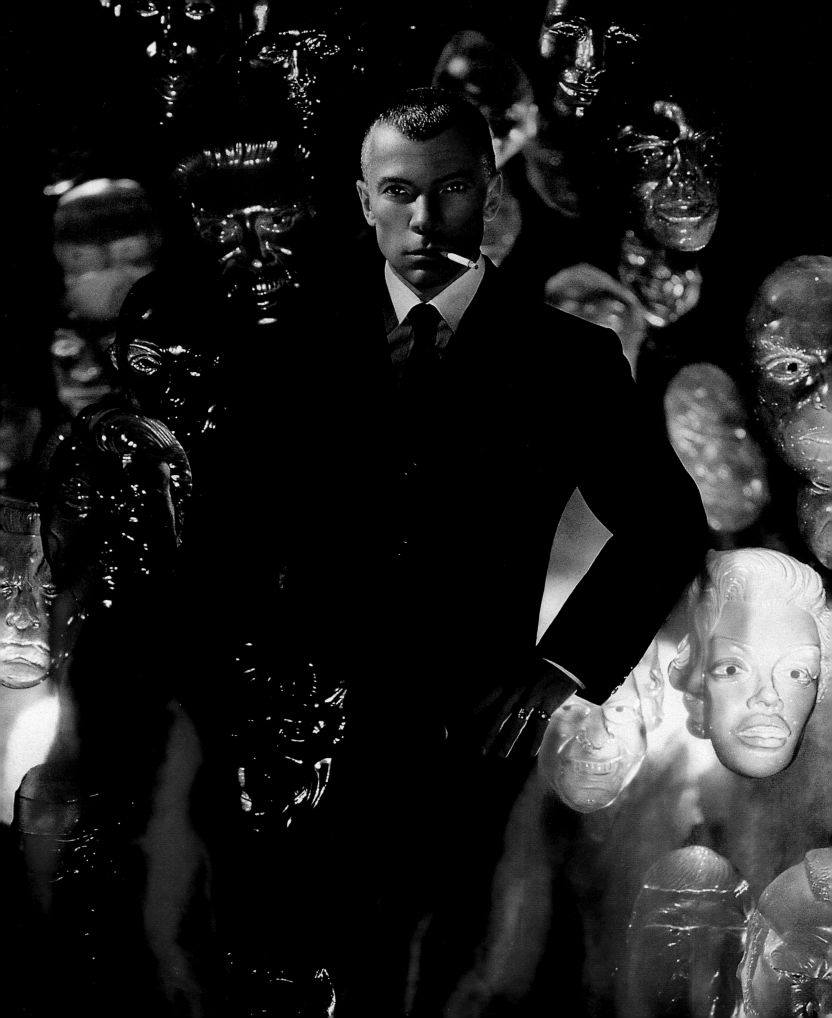

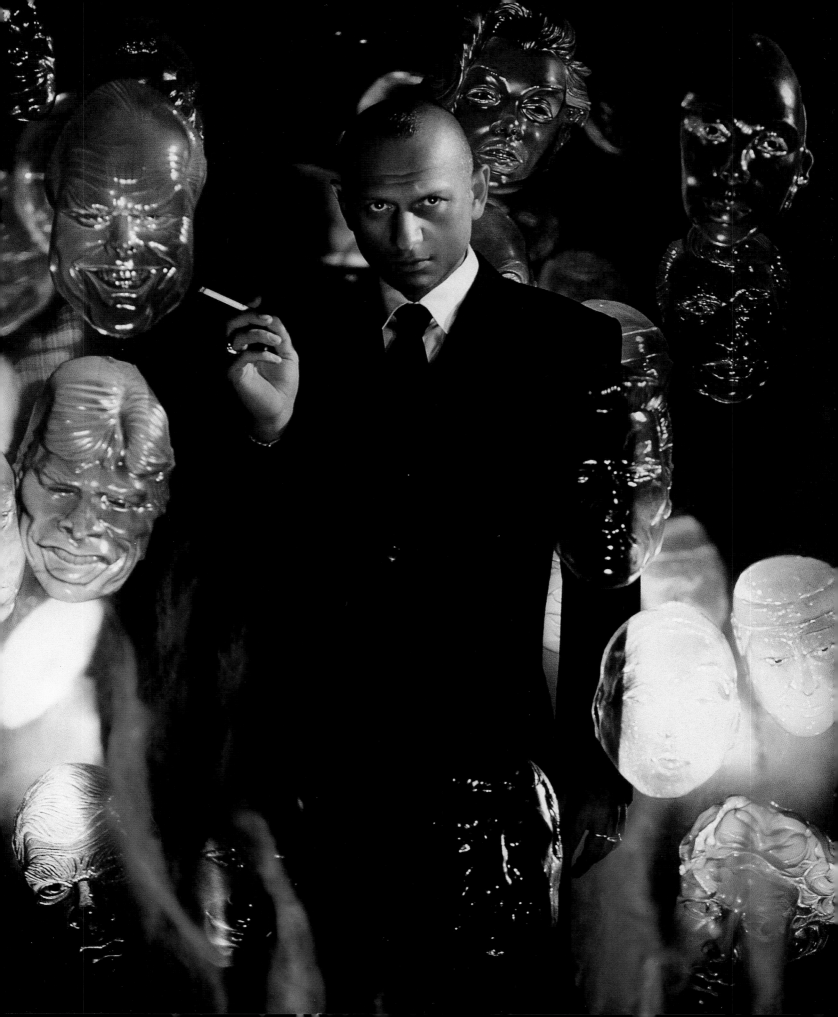

Pierre

Gilles

MERRELL

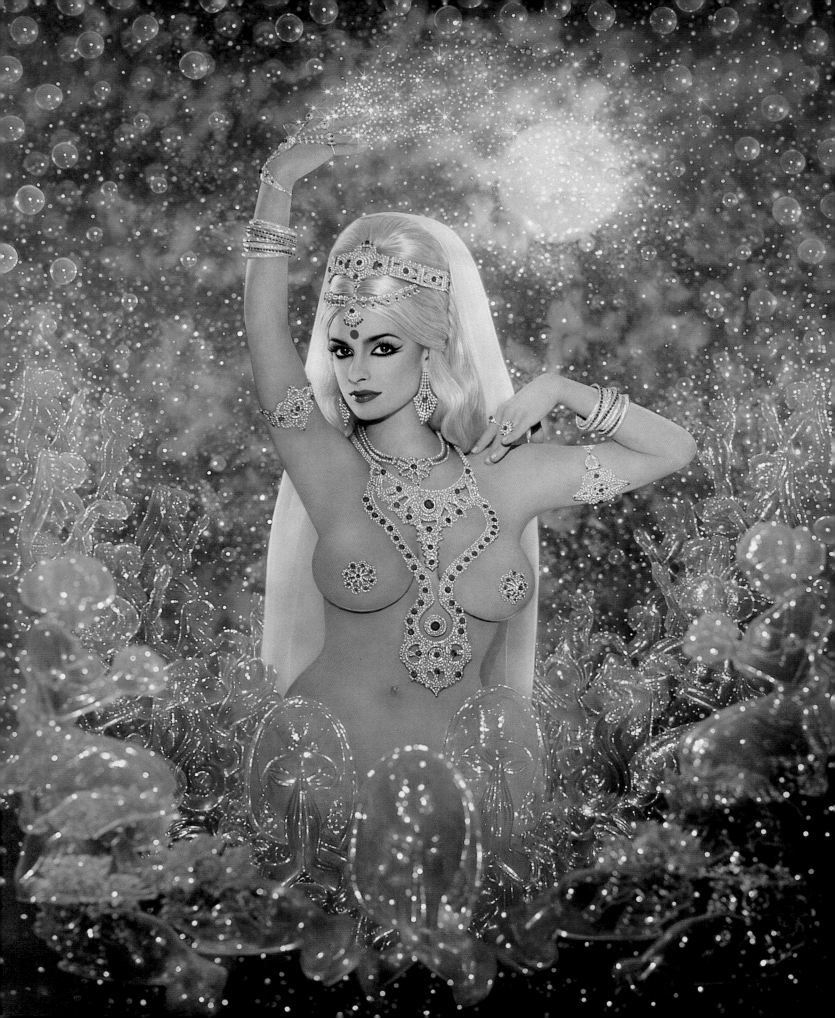

Contents

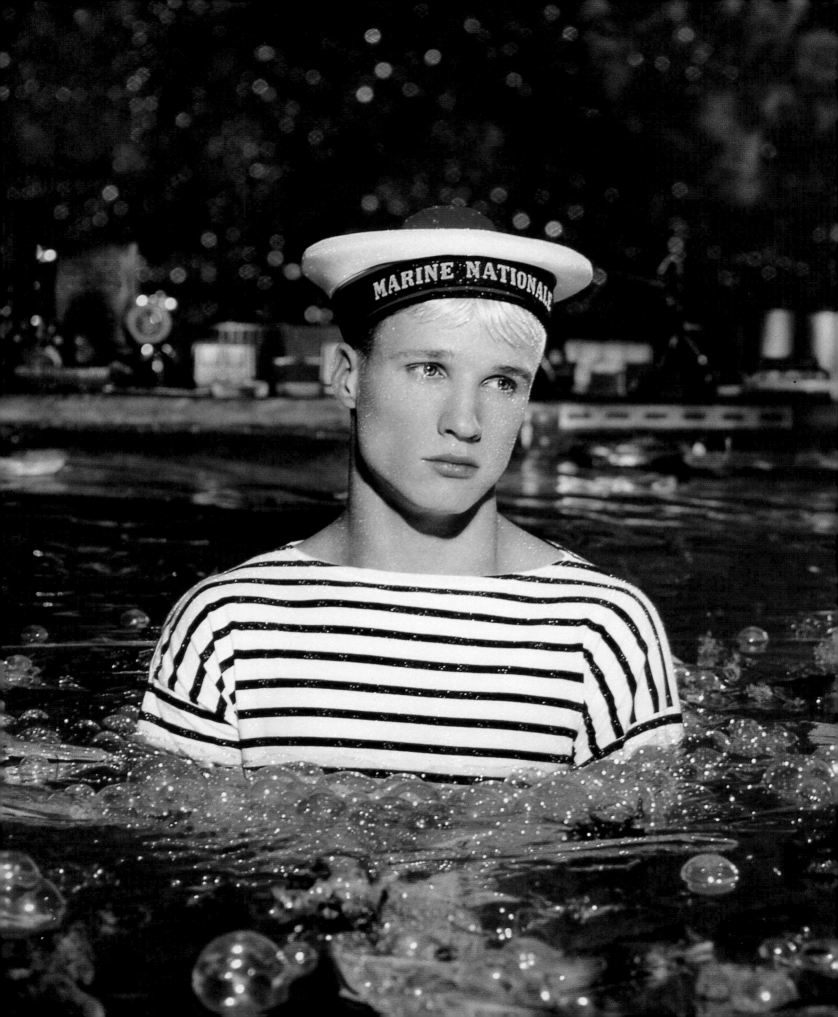

Foreword

It seems especially appropriate that the New Museum is the first U.S. museum to present a survey of the work of the collaborative team Pierre et Gilles. Central to the New Museum's mission is the belief that contemporary art has the power to affect the lives of all people, and the work of Pierre et Gilles is enjoyed by a broad cross-section of the public who respond intuitively to the French duo's work.

It is virtually impossible to look at the work of Pierre et Gilles without smiling. Their obvious pleasure in *making* art reminds the viewer of the pleasure in *looking* at art. Even when approaching more somber subjects, the unbridled pleasure they take in color, in composition, and in their subjects gives their work its hallmarked unself-conscious optimism. This optimism, which makes even the tears shed by their subjects fetching accessories to their preternaturally beautiful faces, is a delight for viewers who may be more accustomed to cynicism and a gritty reality.

Another tenet of the New Museum's mission is the advancement of innovative art and hybrid forms. Pierre et Gilles embody this idea by providing a seamless transition between the real and the idealized, between photography and painting, and between art and popular culture. Their broad embrace of lifestyles, subjects, and iconography, and their matter-of-fact presentation of a vast range of issues exemplify the potential art has as a vital social force. It is also an example of cultural globalism — a term that has become a neat and stylish catchphrase in recent years, but which has been an integral part of the work of Pierre et Gilles since they began working together twenty-five years ago.

Through their work — by turns exuberant, poignant, but always heart-felt — Pierre et Gilles remind us of the power of the individual, and this is truly a tonic as we begin the new millennium.

Lisa Phillips

THE HENRY LUCE III DIRECTOR
New Museum of Contemporary Art

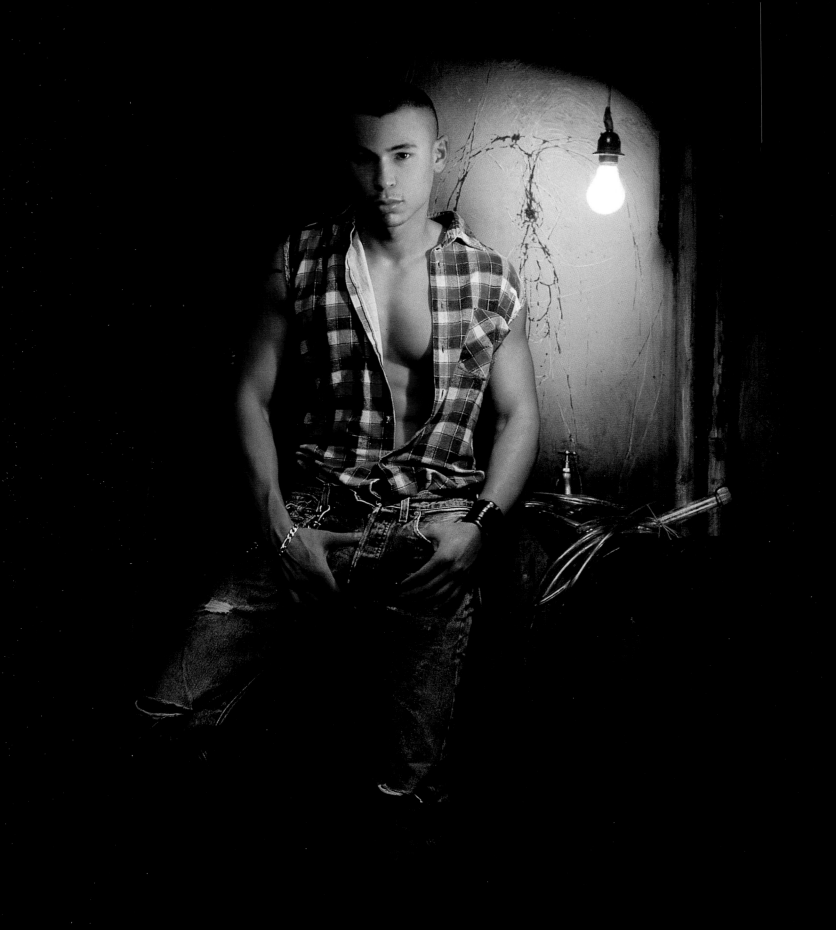

Acknowledgments

Transporting an artist's work from one cultural context to another is often a risky enterprise. Mistranslation lurks in the wings as a potential hazard, and the fear that one country's ecstasy might result in another's ennui often pervades our attempts to bridge the more daunting cross-cultural gaps. This partially explains why the art of Pierre et Gilles offers one of the rarest of opportunities: the product of a particular time and place (turn-of-the-millennium Paris), it nevertheless speaks to a much broader public than is typically the case for contemporary art. For American viewers, the work's fusion of symbols and subjects from a wide range of cultural sources (including our own) with key elements of French identity produces an oddly double-edged nostalgia – instantly recognizable yet inescapably exotic.

In crediting the numerous individuals who have made this project possible, the most important thanks go to Pierre et Gilles, who have been extremely generous in offering their time and insight into the selection and interpretation of their work. Most artists are understandably pleased when an exhibition of their work is being organized, but Pierre et Gilles have been unusually warm and good-humored collaborators, and I found their assistance invaluable. An equal debt of gratitude is owed to Vincent Boucheron and all at the Galerie Jérôme de Noirmont, who have been extraordinarily resourceful and flexible in helping to initiate and sustain contacts with the many collectors who have given us permission to borrow and display their treasures. In this same category are the collectors themselves, whose excellent taste and judgment in acquiring these works often seems to be rewarded primarily by their being cajoled into living without them for extended periods of time.

This exhibition could not have taken place without the generosity of *Etants données*, The French-American Fund for Contemporary Art, who have been enthusiastic supporters of this exhibition since its inception. A particular note of thanks is owed to Antoine Vigne, Cultural Attaché, Les Services culturels de l'Ambassade de France aus Etats-Unis, and to his predecessor, Estelle Berruyer.

The New Museum is extremely pleased to be collaborating for the first time with Merrell Publishers in the publication of this catalogue, and special recognition goes to Hugh Merrell for his spirit of enterprise and sensitivity. My colleague William Stover's hard work as Publications Manager was essential to the arduous process of developing this publication from a mere wisp of an idea, and in arranging the exhibition's subsequent travel to the Yerba Buena Center for the Arts in San Francisco. Assistant Curator Anne Ellegood's overseeing of the frequently difficult process of loan requests was invariably smooth and good-natured. Even with all this support, the most vital support came, as it always does, from The Henry Luce III Director Lisa Phillips, Deputy Director Dennis Szakacs and Exhibitions Manager John Hatfield. This project gives me the opportunity to reflect once more on how fortunate I am to work with such committed and inspiring individuals.

Dan Cameron
SENIOR CURATOR
New Museum of Contemporary Art

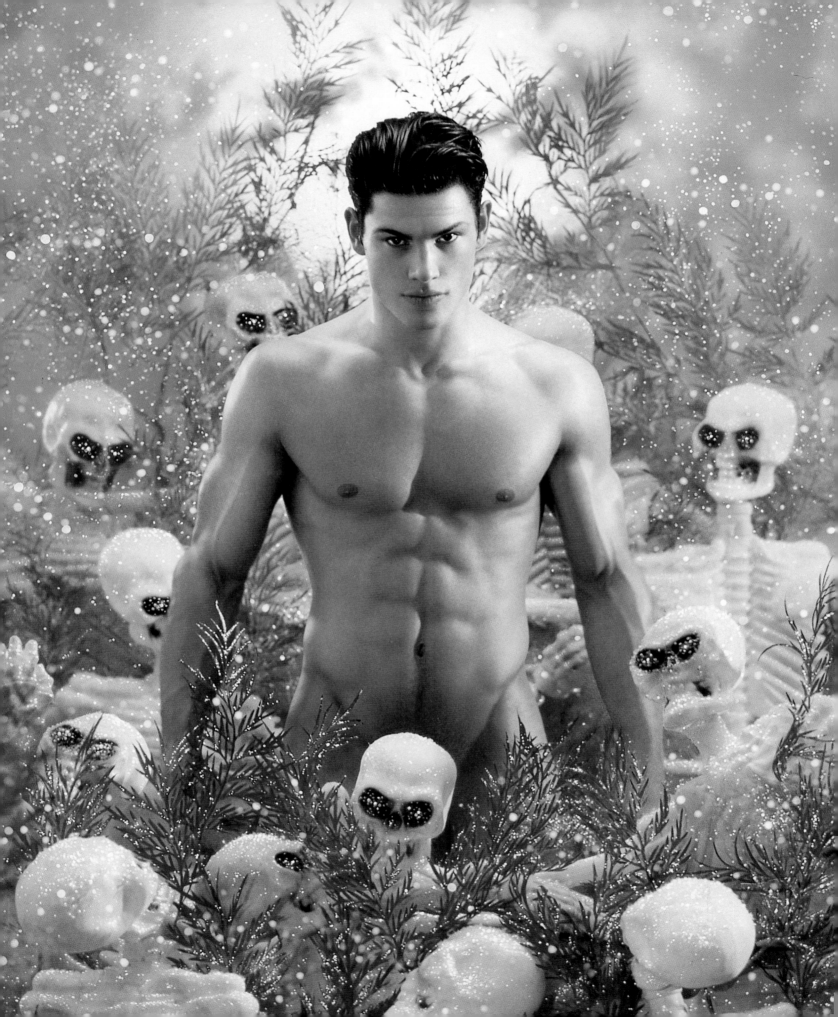

LOVE

The Look of

The Art of Pierre et Gilles

Dan Cameron

INTRODUCTION

This exhibition of the French artists Pierre et Gilles, their first museum survey in America, comes at a pivotal moment in the discourse surrounding contemporary art. Such points of flux tend to be accompanied by drastic overhauls in taste, both in the appraisal of certain artists' work, as well as in broader reversals of values that transform a diverse range of ideas and practices. In the present case, the transition seems to have been sparked by the extraordinary proliferation of visual stimuli in contemporary life, a change that has not been accompanied by any corresponding rise in overall visual literacy. As a result, the dominance of digital media and the increased use of information technology at every level of daily life have created a broader communication gap, rooted in art's historic failure to have made its case convincingly to the public. Faced by the dwindling interest in new art and the

monolithic growth of electronic media, visual culture has been slowly transformed into a more hybrid form, in which multiple and often contradictory expressions seem to co-exist in a kind of perpetual holding pattern.

Of all the points of contention that have dogged art during the past thirty years, none has polarized debate as effectively as the morass of disputes surrounding popular, or mass, culture. While some accuse mass culture of sheer banality and rail vainly against its omnipresence, others hail it as the validation of a counter-cultural ideology that dismantles the élitist hierarchies of the past in favor of a new cultural democracy. Somewhere in between these two extremes is a third line of thought, which suggests that all artistic expression is intrinsically popular, in the basic sense that it is meant to appeal to someone other than the individual(s) who created it. Despite the bizarre trajectory of the twentieth century, which produced a deep and seemingly unbridgeable schism between artists whose work is presented in museums, and those featured in movie theaters, television or magazines, such distinctions are no longer as binding as they may have seemed even twenty years ago. Partly as a result, estimations of critical or market value based on the scarcity of the unique object are giving way gradually to values favoring the capacity of an object to project an indelible image. By the same logic, an image that can be infinitely reproduced fares considerably better in the age of digital reproduction than one that depends on subtler qualities of texture, surface or materials. While such over-simplification can be dangerous, it is nevertheless becoming possible today to articulate a new set of critical standards based on the directness with which an artist is able to make fundamental points that the average viewer can comprehend.

Since they began their collaboration twenty-five years ago, Pierre et Gilles have done as much to redefine the limits of photography as virtually any other artists working today. In making such a sweeping claim, it may appear self-defeating to point out that this is not the way their work is usually understood, even by their most fervent supporters. Still, from the outline sketched above, an argument can be developed for their painted photographs as the

contemporary record of an image-rich universe, brimming over with pleasure, beauty, and all the inherent drama of religious allegory. Ironically, the sole means by which Pierre et Gilles could construct this hyper-modern world was by appropriating the most archaic themes and compositional devices they could find. Adding to this irony, especially in light of the argument offered above regarding the demands of new technology, is the fact that Pierre et Gilles employ no digital techniques to enhance their work. Each image, from its elaborately constructed set to its intricately detailed hand-painting, is produced through a lengthy and arduous process, which results in a unique, irreplaceable object. If their rarefied status seems to belie the ease with which Pierre et Gilles' images lend themselves to reproduction in limitless formats and quantities, this contradiction can partly be explained by the artists' deeply conflicted relationship to the pictorial tradition. Despite the easy availability of software and tools to create comparable effects, Pierre et Gilles insist that the only way to produce their images is through the painstaking labor of craft. But this is a difficult position to have taken in the last quarter of the twentieth century, and their shared ambivalence concerning the restraints of tradition can be measured by the degree to which they load their work with irony and mixed messages.

From our particular point in history, the powerful grip that modernism and the principle of the avant garde had on twentieth-century art was equally liberating and confining. While the first half of the century would have been unthinkable without the driving belief in modernity to propel its rapid evolution from Post-Impressionism to Abstract Expressionism, the spark had clearly gone out by the time Clement Greenberg's brand of formalist reductivism killed off modernist abstraction in the 1960s. Not surprisingly, the rush of stylistic innovations and new critical ideas that occurred at the end of the 1970s was closely tied to the articulation of a post-modern sensibility, which prized the creative rethinking of past modes and styles in favor of endless reconfigurations of the new. This point bears emphasizing in relation to Pierre et Gilles because one of the most serious gaps in knowledge about their work concerns its emergence from the same seismic shift in visual culture that produced Cindy Sherman and

other photo-appropriation artists in the U.S. While American viewers may have trouble attaching the same critical pedigree to Pierre et Gilles' portraits of saints as they do to, say, Sherman's photo-renderings of B-movies' mythology, the difference may lie in distinction of cultural perspective. Both artists are operating in a pictorial niche that straddles popular culture and art history. Where Cindy Sherman locates her allegories squarely within the cinematic tradition, however, Pierre et Gilles prefer to submerge themselves in the more sentiment-laden (and therefore debased) underworld of keepsakes, tinted postcards, outdated physique magazines, and old movie posters. In other words, not only have Pierre et Gilles' choices of source material been genre-driven to the extreme, but also, from the beginning of their collaboration, the artists were adamant about creating a visual universe that was unmistakably and deliriously gay.

HIERARCHIES OF DESIRE

In seeking to ascertain the appropriate degree of significance to ascribe to Pierre et Gilles' contribution as artists, sexuality plays a key role. Not only are they among the most visible gay artists in the world, but their fame also extends far beyond the art world's limits, infiltrating the fashion, publishing, and music industries as well. Their subject-matter gleefully embraces a predictable range of gay-related themes, from movie queens and music divas to muscle boys and porno stars, and they pioneered the enshrining of the gym-built male physique as the erotic focal point of our age. Cleverly blurring the lines between kitsch, camp, and what currently passes as glamor, Pierre et Gilles enact a Warholian fantasy by situating their friends on the same worshipful pedestal as the famous and/or notorious models who visit their studio for commissioned portraits. In fact, Pierre et Gilles are so aggressively upbeat and loose about their sexuality that it is impossible not to wonder to what degree this position has also cost them points in the ranks of so-called serious artists. Certainly, the potent combination of their gayness, their disinterest in the

critical avant garde, and their fervent embrace of pre-modern tropes and pop-culture flourishes have not discouraged anyone's natural propensity to categorize their work as minor. Although it might seem unthinkable today, even such an explicitly gay artist as Andy Warhol held strong misgivings about making his sexuality a matter of public record, and once he began to stray from the accepted constraints of art-world practice — *Interview*, society portraits, celebrity worship — his standing within the art community took its deepest plunge.

Perhaps we can consider the question from a slightly different angle, and propose that Pierre et Gilles have not simply engineered a breakthrough in the public reception of explicitly gay art, but they have also made their sexual identity an essential reference point in literally everything they create. While this strategy links a diverse range of American artists, from the visionary art of David Wojnarowicz to the AIDS-inflected conceptualism of Felix Gonzalez-Torres, the case of Pierre et Gilles is different in part because they are French, and because their work predates the above-named figures. The fixing of historical signposts in this instance is essential, since their mature style developed several years prior to the appearance of AIDS. For this reason their sensibility has a more fundamental connection to the cathartic impact of the Stonewall rebellion in 1969, and the utopian tendencies of the early years of the gay liberation movement (the porno-comic art of Tom of Finland being the classic example), than to the political urgency of the past two decades. Although the ecstatic dimension of their art might appear naïve, or at least disingenuous, to gay men who feel no direct link to the immediate post-Stonewall era, the fact that Pierre et Gilles have sustained this vision throughout an epidemic that has had a catastrophic toll on public health suggests that they believe the championing of even the most rudimentary gay values is in itself a polemical act. Put simply, one could argue that Pierre et Gilles' work offers a passionate argument that the projection of an unflinchingly idealized gay identity remains one of the few culturally subversive gestures possible in a society that ascribes a second-class legal status to gays and lesbians. Viewed in this light, the argument that Pierre et Gilles' art is inescapably minor seems

tantamount to proposing that the only way to create art from an explicitly gay perspective is either by reducing its degree of explicitness, thereby (in theory, anyway) heightening its inclusivity, or by rendering it as farce.

This last point deserves to be underscored, if only because Pierre et Gilles' inherently subversive relationship to the way meaning is constructed in purportedly serious art becomes essential to understanding why their art's potential for long-term consequence may be greater than many observers seem willing to admit. To make this relationship clearer, we can consider a couple of their works as articulations of a gay-idealized perspective. One of their earliest and best-known pieces, *Adam et Eve ~ Eva Ionesco & Kevin Luzac* (1981), depicts a young and unmistakably contemporary naked man and woman in the heart of pre-expulsion Paradise. Despite the *faux* modesty with which the girl's hair curls around her breasts, or her arm reaches back to protect her buttocks from appraisal, there is nothing shy about either model's body language in relation to each other and the viewer. On the contrary, they stare at us brazenly, with an erotic charge that suggests that we, too, might enjoy the next installment of their guilt-free frolic. This lingering sexual stare, as prevalent a motif in gay (and other forms of popular) culture as it is rare in the vocabulary of recent painting and photography, transforms the story of Genesis into something like a steamy advertisement for an early 1980s singles' resort. The natural proportions of the two models, and their unvarnished joy in being themselves, cues us that while this is a far cry from the exploitative use of nudity to sell products, it has even less in common with the dour moralities embedded in the biblical tale of the earth's first couple. By fostering such a combustible fusion of religious sentiment and erotic awareness, Pierre et Gilles make *Adam et Eve*, the first of innumerable pictures based on religious themes, into a pointed rejection of critical dogma surrounding representation. In successive treatments of religious material, Pierre et Gilles have stretched the link between the models' physical beauty and their saintly attributes even further, making their interpretation a camp exaggeration of myth that nevertheless succeeds in bringing the myth alive in the present moment.

Adam et Eve ~ Eva Ionesco & Kevin Luzac (1981), detail

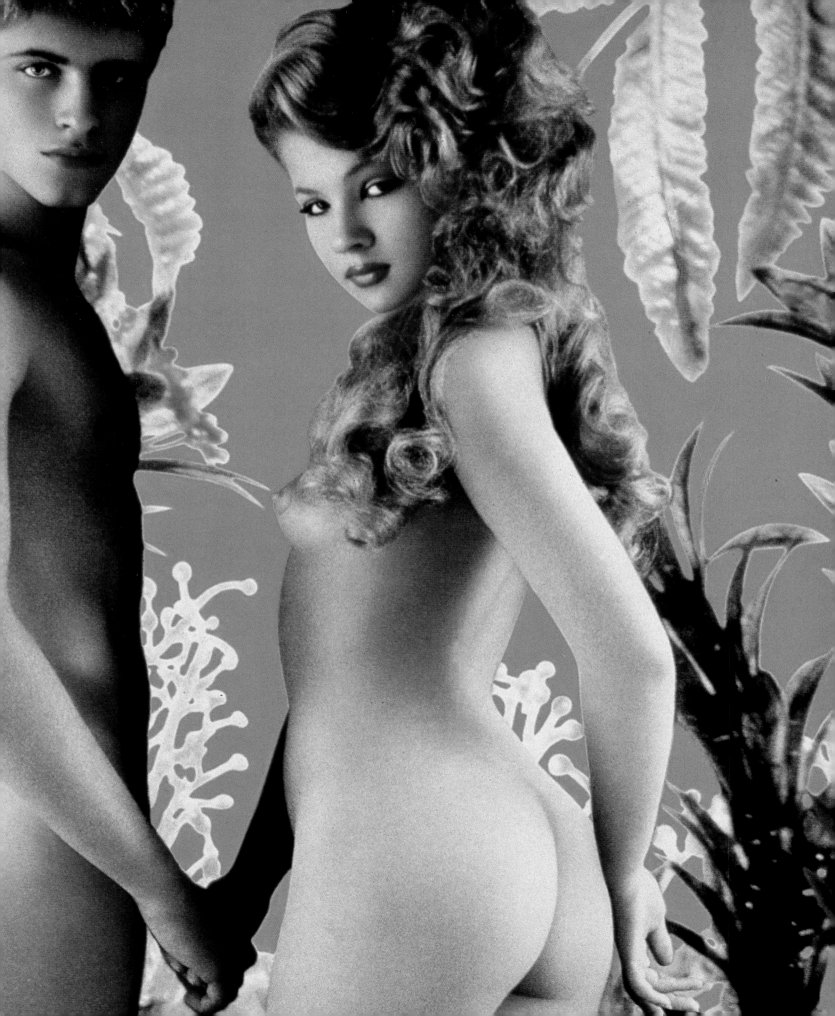

There are obvious formal points of comparison between Eve's kittenish pout and *Saïd ~ Salim Kechiouche*, the smoldering subject of a work from 1999. Taken from the story line of a recent film titled *Les Amants Criminels*, a towel-clad man gazes intently back at us over his left shoulder, twisting from the hip in perfect synchronization with Eve's alluring swivel. Although the atmosphere is erotically charged, it is not clear whether Saïd's look is an invitation or a warning, and the ambiguity can be understood as explicitly gay (rough trade) in its codification. While Saïd's expression suggests that he might either proposition or threaten us, the chaste quality in the way his face and torso are photographed makes him seem oddly feminine. Not unlike the swingers' subtext of *Adam et Eve*, the tension in *Saïd* is elusive if one does not employ the filter of a locker-room pick-up to interpret it, and this degree of explicitness is calculated to make a portion of Pierre et Gilles' audience feel either aroused, uncomfortable, or both.

My argument is that this discomfort zone is crucial to grasping the core meanings in Pierre et Gilles' work, since it partially echoes the debate over assimilation that has recently gained momentum in the gay community. In effect, Pierre et Gilles' position seems to be that, because the historical blueprint for modernism either ignores sexuality outright or treats it as implicitly heterosexual, one of the first obligations for anyone setting out to create a gay culture is to articulate the differences between gay and non-gay experience. This helps to explain why the percentage of Pierre et Gilles' work that might be defined as gay erotica is so high: sexuality is still the irreducible core of this difference, and for that reason alone its depiction requires our full attention. It also makes an important but generally overlooked distinction between the way gay culture views the icons and narratives of non-gay culture and the way non-gay culture looks at itself.

Although explicit homoeroticism does not account for the full range of gay readings one can find in Pierre et Gilles' work, it nevertheless provides an important gauge for measuring their commitment to exploring erotically charged scenarios as free-play zones for the

Saïd ~ Salim Kechiouche (1999), detail

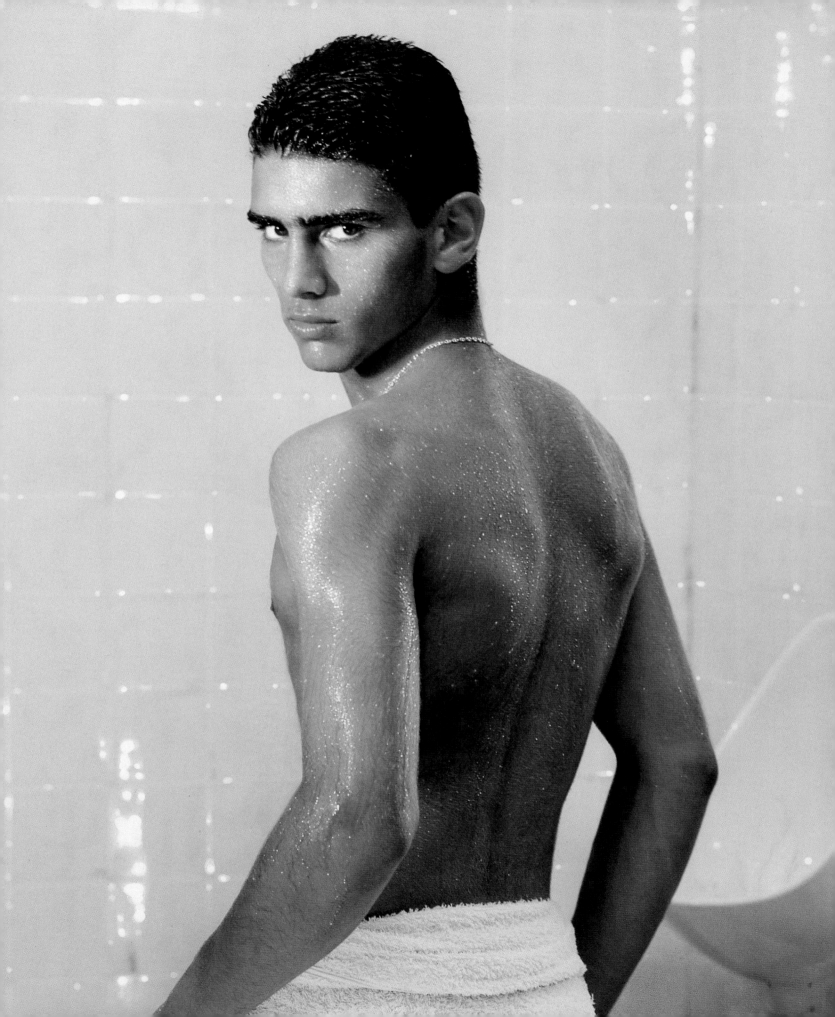

imagination. By disco-era standards, for example, the bare-buns pose assumed by the model Victor in the early *Le Cow-Boy ~ Victor* (1978) may have been somewhat risqué, but to our eyes it is already an opaque relic from another time and place. The unabashedly silly costume (holster, hat, scarf, gloves, boots, and gun) against the stars-and-spiral background seem calculated to undermine the utter self-possession on the model's face. As a whimsical parody of the Wild West's stark code of masculinity, there is nothing even remotely tough or transcendent about this image. On the contrary, the work's extreme self-consciousness about its use of a gay archetype manages to rescue it from being a mere study in American trashiness. The artists take one step into the realm of abstraction in the slightly later *Silver Biker ~ David Pontremoli* (1982), featuring the model David, his face, aviator's cap, and open-necked jacket all painted the exact same shade of black. The cool artificiality of the image conjures up a feeling of the impersonality of the hunt for sex, despite the model's wholesome smile and softly angled features. Although *Silver Biker* gets its point across on the basis of its startling absence of realism, it represents an experiment in reductivist sexuality that Pierre et Gilles would never choose to repeat.

A more recent and complex treatment of sex can be found in the series *Les Plaisirs de la Forêt* of 1995–96. Although Pierre et Gilles have worked on series before, their formats have tended to be open-ended, with few direct connections between individual works in any given series. In *Les Plaisirs*, however, each image offers a distinct interpretation of the erotic possibilities lurking in the woods at night, with a visual coherence to the series that suggests that all the depicted activity is taking place simultaneously at different spots in the same forest. While the motif of sex in the woods draws on predominantly gay customs, and indeed the majority of the habitués of these scenes are men standing or crouching alone, Pierre et Gilles have managed to populate the dramatically lit clearings in these works with a relatively diverse group of revelers. While Jiro Sakamoto, nude, stares outward into the night, his head and shoulders drenched in fake blood, as if in mid-swoon over the violent attentions of his now-

Les Plaisirs de la Forêt ~ Jiro Sakamoto (1996), detail

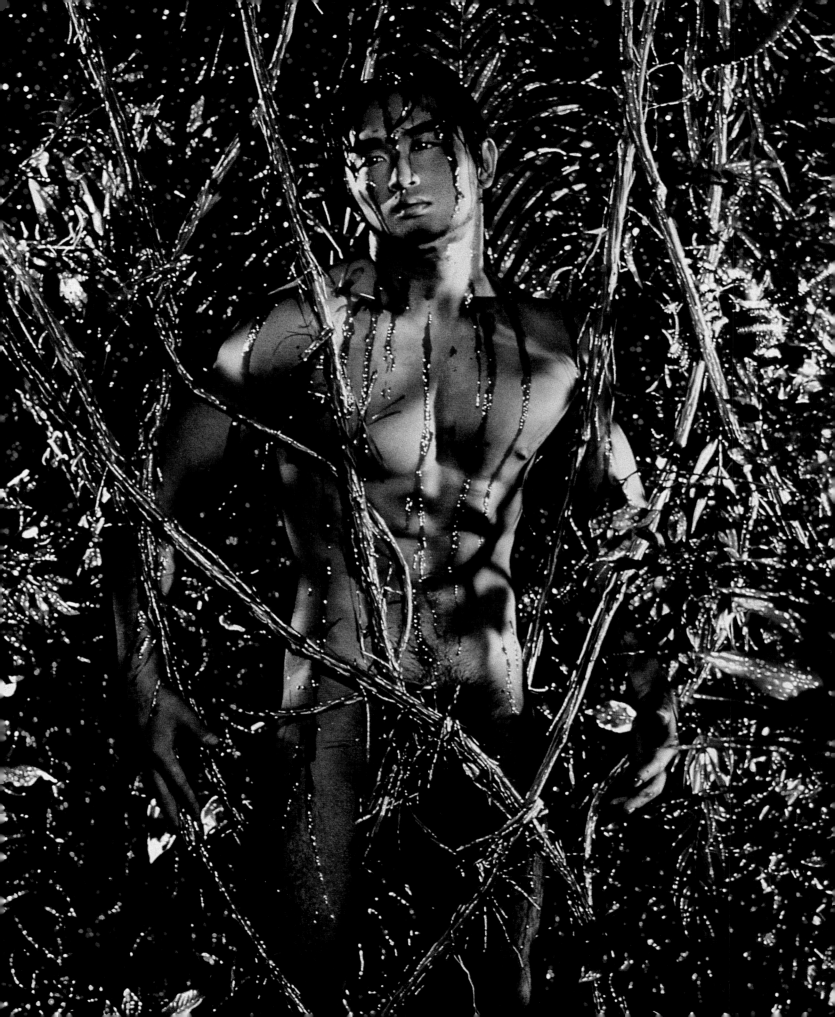

departed partner, the model Marc Anthony, in hiking boots, leather harness and biker's cap, coyly cups his hand over his genitals while seeming to beckon us forward for a closer look. The most sexually charged of the male poses belongs to a model named Johnny, who leans backward with an expression of unquenched lust on his face, his torso splattered by the photo-stylist's equivalent of semen.

The women in the series are posed in somewhat more conventional positions, although their wardrobe suggests an equally fantasy-driven quest. Lola, a peroxide blonde in clinging lamé dress and fur boa, attempts a look of mock-innocence, the fix of her eyes resembling a deer caught in a car's headlights. Polly, one of Pierre et Gilles' most frequently used models, appears as a druid queen escaped from a fantasy novel: her shaved head topped with a small crown, she holds up a darkened hand-mirror as her black form-fitting gown spills into the underbrush. The most complex work in the *Plaisirs de la Forêt* series, featuring the models Etienne, Sarah, Bob and Pete, at first seems to contain only two figures. Etienne, his face bloodied and shirt torn, is lying in the arms of the unscratched Sarah, as the two of them gaze into the night in the apparent direction of his attacker. Only gradually do we become aware of the faces of two men hiding in the brush, peering voyeuristically out at the two lovers. Although the narrative of the scene might not hold up to prolonged scrutiny (the discarded wooden flute is an especially incongruous detail), the visual drama of the piece, unusual for Pierre et Gilles, is enhanced by the composition's rounded-off edges, making it appear as if we are studying the lover/victims through a lens, perhaps even from the vantage-point of the escaped attacker.

Les Plaisirs de la Forêt ~ Polly (1996), detail

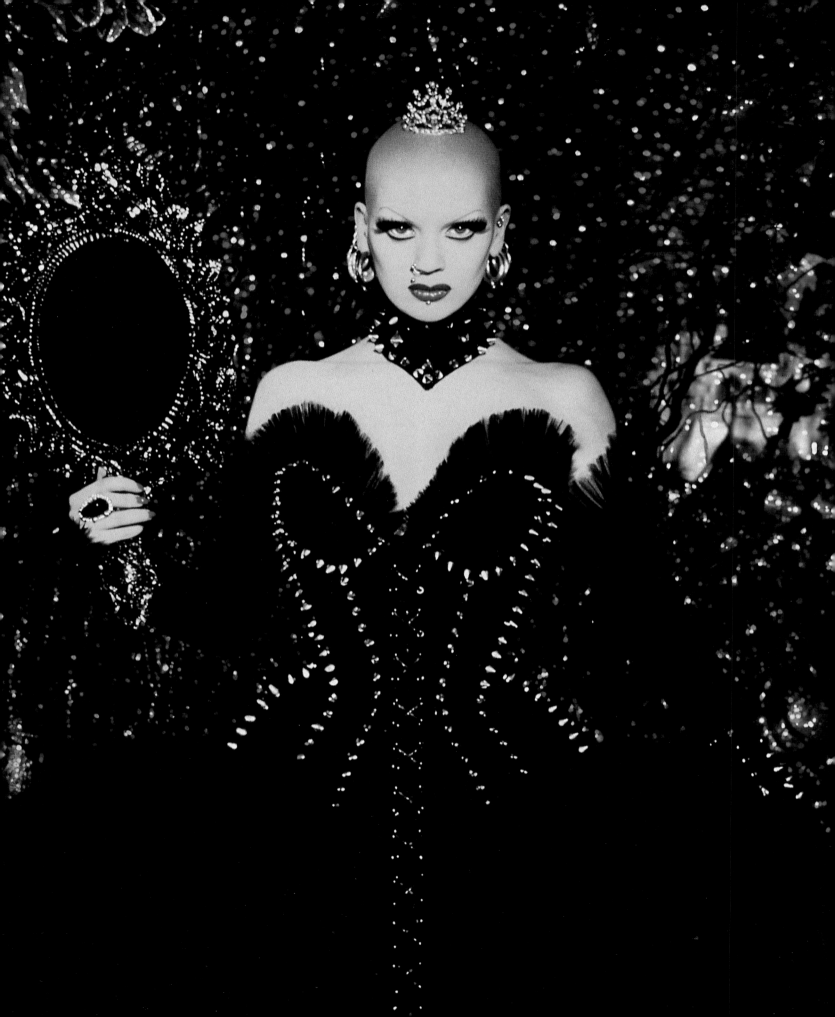

I f homoeroticism functions as Pierre et Gilles' primary means of introducing a sense of physical vitality into an otherwise artifice-driven project, a particularly kitsch-laden brand of camp provides their most distinctive stylistic inflection. However, because it can be so easily misunderstood as either frivolity or cynicism, Pierre et Gilles do not merely employ camp as a working method. Rather, a founding principle of their collaboration has been to defend ardently an elevated position for camp within visual culture. Like missionaries, they promote the realm of sentiment and artificiality as a kind of existential balm, claiming that only the power of illusion can sustain one's hopes when other structures of belief have collapsed. As in life, camp announces itself in Pierre et Gilles' work through a blatant act of subterfuge, but it just as frequently resolves itself by presenting an enigma shaped by our own illusory search for meaning. Especially when dealing with subject-matter that touches on such weighty issues as death or religion, many of Pierre et Gilles' most compelling works provide a transforming lens that reconfigures life's bumpy contradictions into a smooth tissue of perpetual wonder.

The clearest illustration of how camp has evolved in their art can be found by comparing Pierre et Gilles' images of crying men and women from the mid-1980s with a slightly later version, *Le Petit Communiste ~ Christophe* (1990). In the earlier group, which is represented in this exhibition by *Le Marin ~ Philippe Gaillon* (1985), *Le Jeune Pharaon ~ Hamid* (1985), and *Pleureuse ~ Claire Nebout* (1986), tears highlight the angles and smooth texture of the models' faces. Only with *Le Jeune Pharaon* is the viewer motivated to speculate about why the subject might be crying, and even here the exoticizing effect is somewhat dampened by the fact that the artists had not yet, by this point, reached the sophisticated level of set design that they would soon attain. By contrast, with *Le Petit Communiste*, title and composition are clearly references to the fall of the Berlin Wall during the preceding year, and the rapid dissolution of the Soviet Union that followed. Not only does the model's face convey an entirely plausible sense of anguish,

Le Petit Communiste ~ Christophe (1990), detail

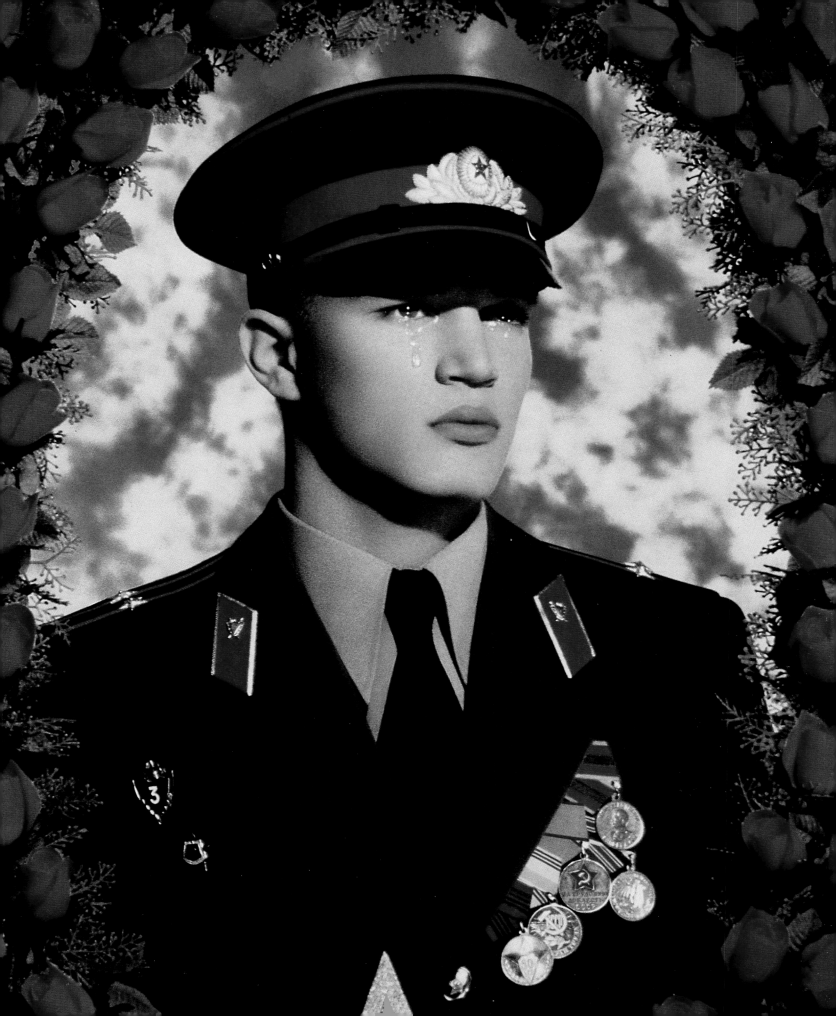

but the combination of the funereal wreath encircling him, and the storm clouds gathering in the background, also lend an unexpected note of drama to a composition that is clearly modeled on commemorative portraits of soldiers killed in war. In this work, Pierre et Gilles may not offer any unexpected insights into politics or history, but they succeed in conjuring up a surprisingly poignant view of the human cost of an empire's collapse.

Other variations on the mechanism of camp humor fill Pierre et Gilles' self-created world, such as a post-coital image of 1983 titled *La Panne ~ Patrick Sarfati & Ruth Gallardo*, which ranks as the most comical photograph they have produced to date. A man and woman sitting upright in bed emanate conflicting interpretations of what has just transpired: the man is alert and supremely self-satisfied, his grin on the verge of becoming a smirk, while the woman's half-closed eyes gaze sideways, as if hoping she were somewhere else. With its 1950s-styled boudoir and exaggerated make-up and hair, the image has a wholesomely absurdist dimension that enables us to gaze on the foibles of erotic love as if from a protected perch. At the opposite end of the spectrum, one finds the unbearably saccharine *I Love You ~ Dominique Blanc* (1992), which radiates the kind of picture-perfect ending that has all but vanished from the cultural landscape. A delicately coifed and garbed woman, symmetrically framed by a gilt-edged doorway, stands holding a bouquet of flowers, her eyes overflowing with tears of gratitude. It is an unsettling image, if only because it exposes the deep desire for acceptance concealed in the impulse to avert one's eyes. In this moment of supreme happiness, the artists seem to be saying, even the viewer's disbelief is subsumed by the universal need to have the story end on a triumphal note.

Pleureuse ~ Claire Nebout (1986), detail

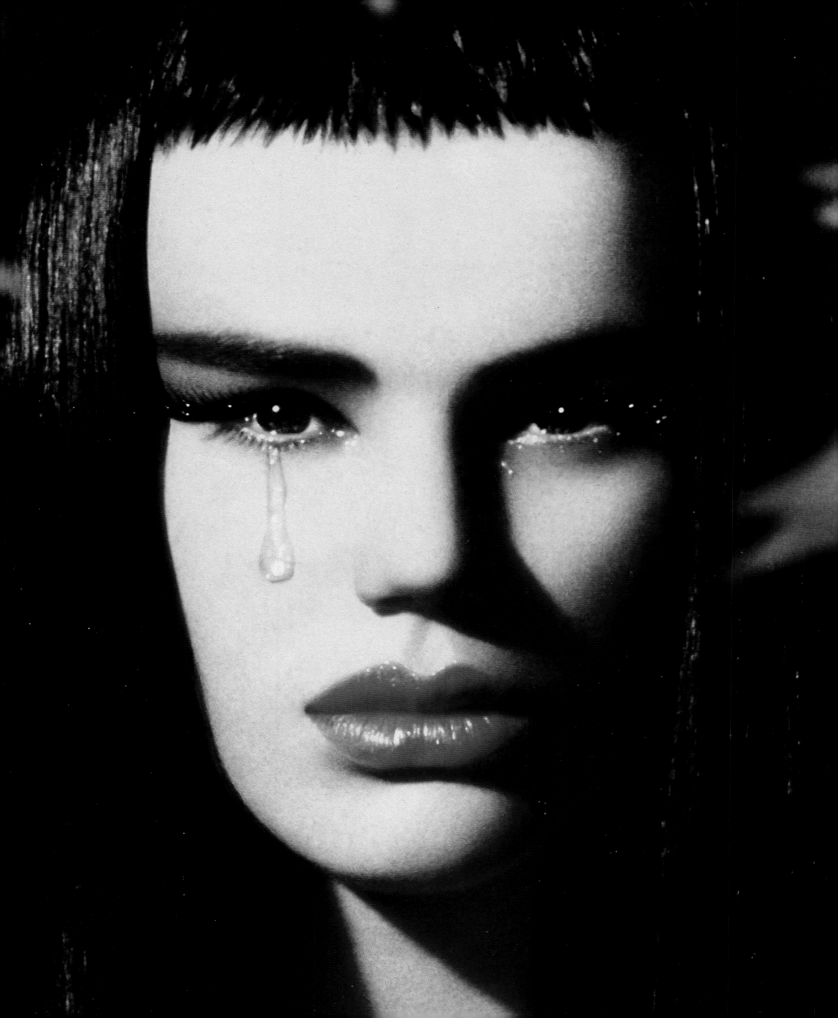

Although at first it may seem to be so closely related to the above remarks on camp that a separate discussion on Pierre et Gilles' portrayal of women is not warranted, the truth is that there are nearly as many images of women in their œuvre as of men. For self-explanatory reasons, Pierre et Gilles do not typically explore nudity in their female subjects, nor do they deploy women in the larger group compositions that have become a growing part of their œuvre. Beginning with the electrifying cheekbones of *Arja* (1979), through the melancholic portrait of Juliette Gréco (1999), the mission seems consistent: to produce an unassailable vision of female beauty as beacon, in which subtleties of character and personality are set aside in favor of a fantasized indulgence in the mythic possibilities of aesthetic perfection. In their early years, Pierre et Gilles approached their subjects almost like abstractions, as in the portrait of *Dovanna* (1983), whose torso emerges gamine-like from a thicket of clustered branches that never quite convince us of their outdoor location. It is not until Pierre et Gilles begin creating more narrative scenarios in which the models serve as quasi-actors that the possibility of touching on an individual's inner life makes itself felt. A series of mostly celebrity portraits from the 1990s makes this point succinctly. In *La Reine Blanche ~ Catherine Deneuve* (1991), ethereal mists surrounding the actress join with the billowing form of her gown to produce an iconic representation of fame, with Deneuve as the lonely prisoner of her own immortality. By contrast, a riveting portrait of *Eliane Pine Caringhton ~ Elian* (1992) suggests a Bloomsbury-era gender masquerade, in which the eccentrically elegant subject, her cigarette-holding arm perched jauntily on its opposing elbow, ferociously arches one eyebrow as she meets the viewer's gaze with something close to disdain.

Although Pierre et Gilles nurture a Warhol-like fascination with fame, they especially enjoy coaxing their celebrity subjects to collaborate with them in extending the dimensions of make-believe to include their own public image. Their well-known portrait of the singer Nina

Eliane Pine Caringhton ~ Elian (1992), detail

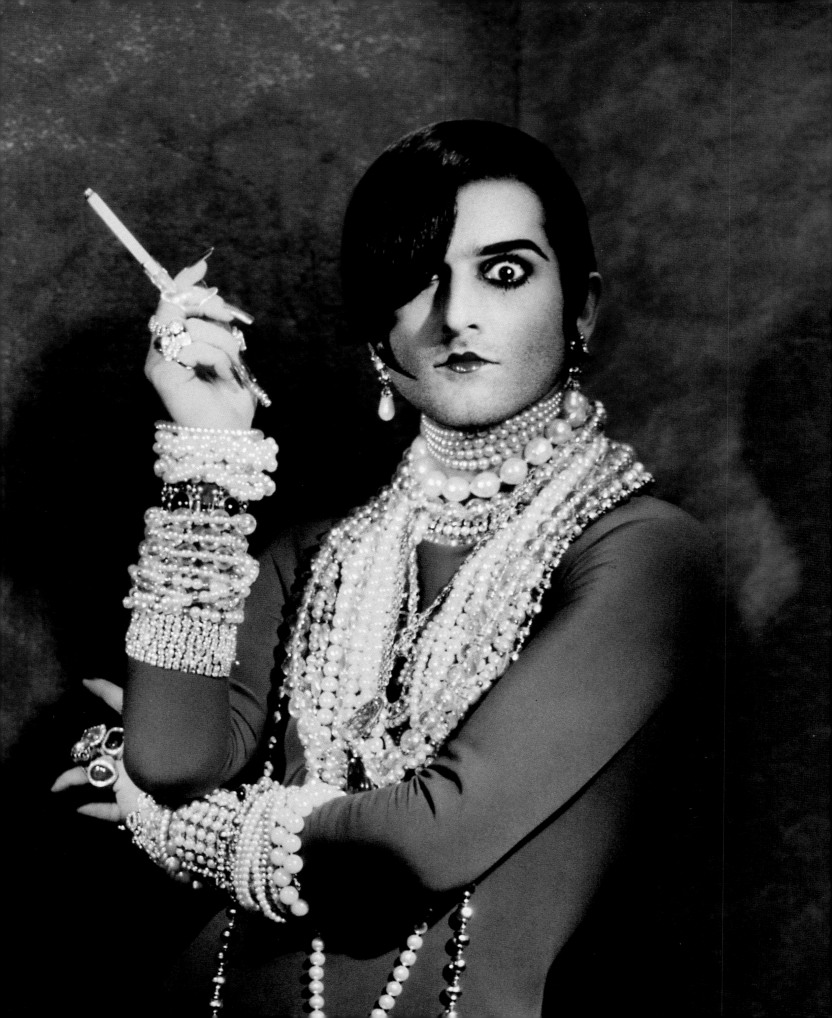

Hagen (1993), clad head to foot in rubber and securely bound to a kitchen chair, lends a domestic calm and mundaneness to the otherwise provocative spectacle of sadomasochism. We do not know or care if Hagen is actually a devotee of kinky sex, but the sly humor implicit in her expectant gaze and the tacky living-room set in which she is posed make it appear as if she has been sitting happily like this for hours, and will continue to do so until somebody comes along and 'rescues' her. Similarly, when Pierre et Gilles capture the French singer Sylvie Vartan as *Ice Lady ~ Sylvie Vartan* (1994), the juxtaposition of her stylized radiance and the icicle props that frame the image also instill the work with the breathless quality of a fan's rapt devotion.

Of the many series that Pierre et Gilles have created over twenty-five years, none is as extensive or as long-term as their portraits of saints, which they began making in 1987 and continue to add to on a sporadic basis. In many ways, this is the iconography for which they are best suited, since the subject-matter plays on both the ambivalence of their feelings about religion, and their persistent search for an object of devotion. By cleverly linking the discomfort of the agnostic or atheist facing these visual myths with the anxiety of devout Catholics unsure whether their faith is being mocked, Pierre et Gilles also make these works particularly resonant for even their most jaded viewers. In both cases, the justification for using images that are so well known as to border on being hackneyed seems to reside in the artists' respective childhoods. Like many children raised as Catholics, the lives and exploits of the saints offer a world of drama and mystery that outstrips nearly anything television has to offer, particularly for those with a fertile visual imagination. As *Sainte Lucie ~ Bernadette Jurkowski*, portrayed in the 1989, calmly extends the plate on which her own eyes are neatly arranged, we are instantly transported to the notion of religious faith as a power that not only appreciates miracles, but also actively promotes them. A different kind of wonder pervades *Saint Sébastien ~ Bouabdallah Benkamla* (1987), whose heroic torso is unconvincingly pierced by a pair of prop arrows. Whereas in both cases the saint's expression is one of beatific acceptance, the hyper-eroticization of the myth of Sebastian converts the story into an unsettlingly vivid example of

Sainte Lucie ~ Bernadette Jurkowski (1989), detail

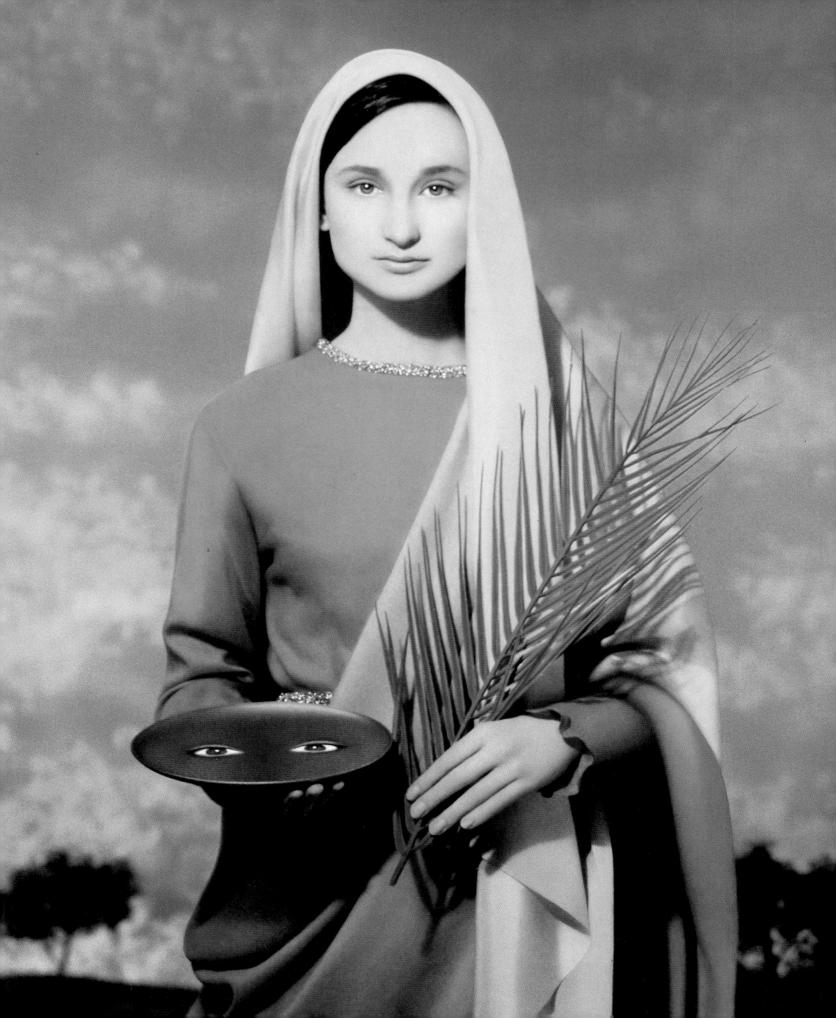

devotion and desire meeting headlong. Such a merging of apparently opposed impulses enables Pierre et Gilles to explore freely the connection between their seemingly idiosyncratic universe and their having grown up surrounded by myths that have produced the most universally accepted icons of European culture.

Pierre et Gilles' drastic revamping of the cause of theology for their own purpose comes through in such works as *Le Purgatoire ~ Marie-France* (1990). In this image, a vivacious black-haired vamp, her gesticulating wrists loosely bound by chains, rises seductively from the fiery mists. Since Purgatory is not traditionally associated with a single person or set of characteristics, the image is meant to embody both the temptations of the flesh as well as the punishment inflicted on an individual sinner. Quite intentionally, however, Pierre et Gilles have created a scene of supposed torment in which neither the sin nor its consequence seems very likely to dissuade others from following in her footsteps. On the contrary, the absence of comparison with either Heaven or Hell makes Purgatory appear as the prelude to an overheated orgy.

Not all of the images of saints in Pierre et Gilles' work depend on as dramatic a contrast between received and reconstructed myths. It is hard to imagine even the most reactionary keeper of the faith objecting to such works as *Saint Martin de Porres ~ Carlos* (1990), *Sainte Barbe ~ Roussia* (1989) or *Sainte Blandine ~ Arielle Dombasle* (1988). In each of these three examples, the wholesomeness and/or holiness of the character functions as a substitute for the narrative place of the miraculous. Since a saint's image is traditionally accompanied by a story that provides the reasons for sainthood along with a case study in how to serve God, viewers tend to interpret this part of Pierre et Gilles' work as providing their few genuine character studies. In the two examples of paired saints included here, *Sainte Monique et Saint Augustin ~ Farida & Salvatore* (1991) and *Saint Martin ~ Marc Almond & Karim Boualam* (1989), the protagonists passively symbolize their saintly attributes with a formality that is surprisingly faithful to the pictorial tradition on which they are based. Possibly the single most unexpected work in this

Sainte Monique et Saint Augustin ~ Farida & Salvatore (1991), detail

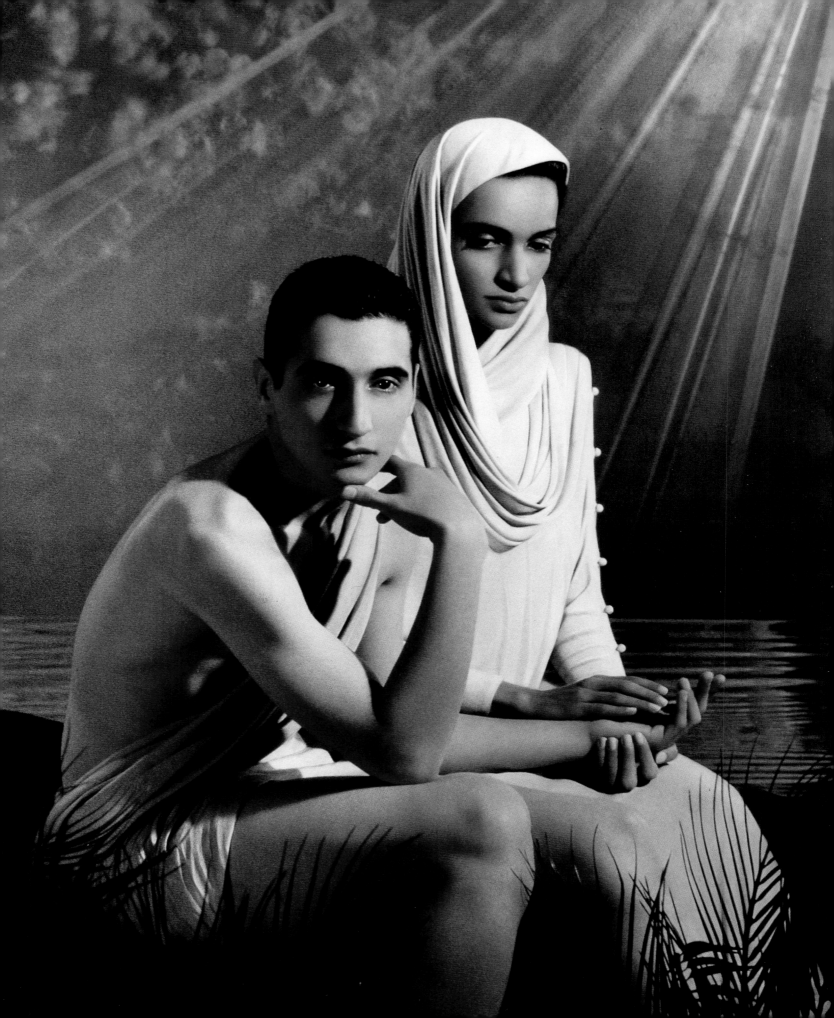

series is *Jésus Christ ~ Philippe Bialobos* (1988), in which a close-up of the model's face becomes the stage for the passion of the cross, complete with a crown of thorns. Along with the requisite trappings of acute physical suffering, Jesus's compassionate gaze seems quite faithful to the New Testament notion of spiritual transcendence. Wedged for the moment between this world and the next, this rendition of Christ does not so much round out the ambiguities in Pierre et Gilles' lives of the saints as suggest that even the closest scrutiny of the mechanics of faith will invariably fail to dislodge its secrets.

An altogether different category of Pierre et Gilles' work might be referred to as their 'pagan saints.' Beginning in the late 1980s, the artists have devoted considerable time and effort to appreciate non-Western religions, especially Buddhism and Hinduism. One result of this study has been an increased interest in depicting deities of all kinds, including those belonging to archaic and non-Western religions. Two early examples of this facet of their work are *Neptune ~ Karim* (1988) and *Sarasvati ~ Ruth Gallardo* (1988), both of which incorporate elaborately constructed settings. Whereas certain aspects of their depiction of the god of the seas fall squarely within Pierre et Gilles' genre of 'beefcake' photography, the aura of serenity found in the saints series has also been transposed on to the model's calm demeanor. In contrast, the composition of *Sarasvati* is more elaborately posed and stylized, incorporating a sitar, headdress, elaborate costume, and a trellis-like framing device that, while incongruous, sharpens the picture's mood of exoticism. Perhaps the most successful of this subgroup of works is the image of *Méduse ~ Zuleika* (1990), in which the tangle of snakes that fall from the model's head contrasts vividly with the placid expression on her face. Gazing at us with perfect aplomb, Medusa is a bit like the sinner in *Le Purgatoire*: beguiling, seductive and thoroughly indifferent to the grave danger she poses for any ordinary mortals who stray into the path of her gaze.

Neptune ~ Karim (1988), detail

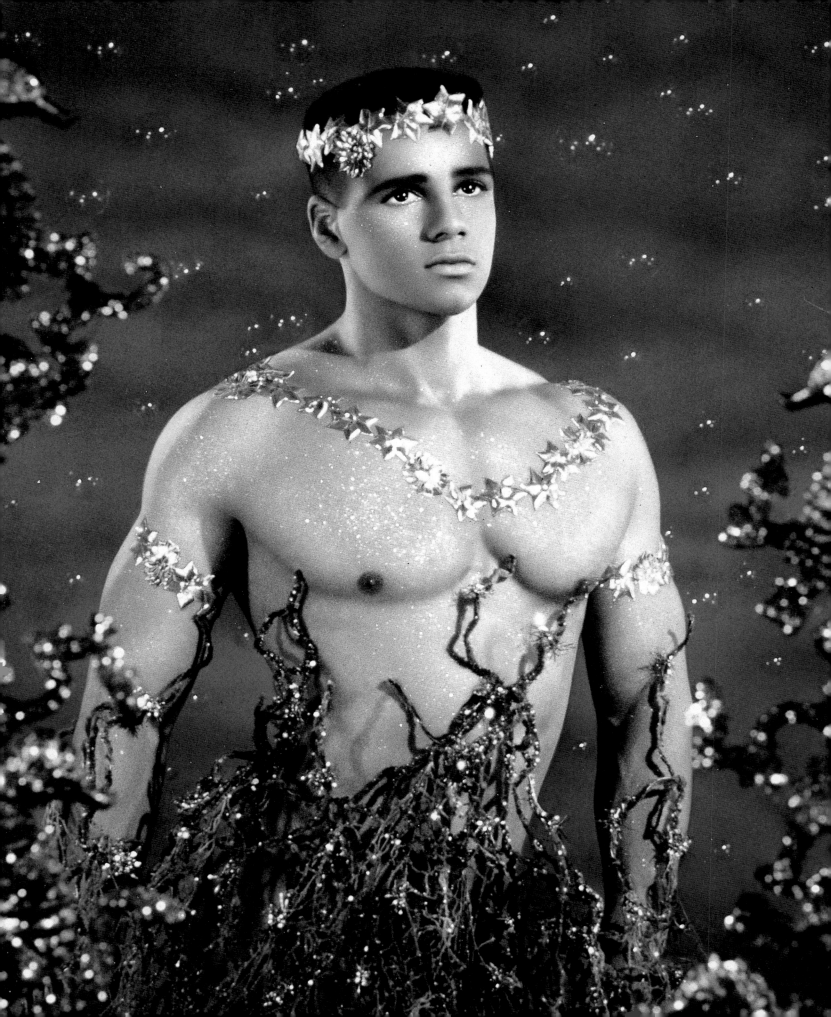

Du ring the 1990s, an unexpected note of melancholy tinged with fatalism crept into Pierre et Gilles' art, providing a new perspective from which to ponder their otherwise ebullient world view. Following the series of saints, and in response to the worsening of the AIDS crisis in Europe and the U.S., death became a grace note, if not the main event, in a growing number of their pictures. A hint of this direction can be seen as long ago as the work *Catherine Blessée* (1984), whose motif — a beautiful young woman sporting a bullet wound to the temple — is echoed in an image from 1998 (*Le Footballeur Blessé*) of a young, freshly killed athlete on the ground. Even the erstwhile Presley lookalike in *Elvis My Love ~ Stavros* (1994), who grips a pistol in one hand, appears to have come to a sudden and untimely end. Sealing the connection both to the saints and to the tear-soaked visages of *Les Pleureuses* and *Le Petit Communiste*, each of these subjects continues to stare sightlessly off into space, as if enraptured by the memory of having been so recently alive.

Rather than merely describe this heightened sense of melancholy in terms of a direct connection with particular events of our day, it can also be considered as the deepening of Pierre et Gilles' artistic vision, an extension of the growing formal complexity that characterized their output toward the end of the 1980s. A trio of works from the early 1990s using one of their most frequent model-collaborators, Tomah, provides some insight into the gradual realization of emotional depth. In *Le Petit Chinois ~ Tomah* (1991), Tomah stands on a low plinth that closely resembles a headstone. Although he is clearly alive, his posture and simple attire, along with the misty Asian landscape in the background, suggests a statue erected in honor of some facet of the Cultural Revolution. The most striking detail is the knife brandished in his hand, suggesting that he is ready to step off his pedestal and kill for the sake of his political beliefs. A year later, Pierre et Gilles produced one of their more incongruous images, *Le Petit Mendiant ~ Tomah*, which features Tomah as a street beggar, his hand outstretched

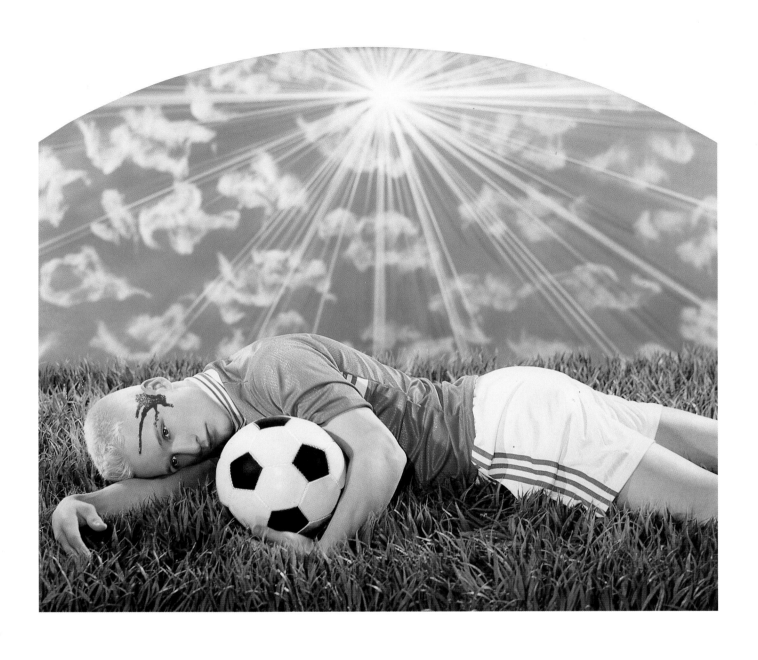

Le Footballeur Blessé ~ Frédéric Lenfant (1998)

toward us. The work's frisson stems both from the gap-toothed expression of pure joy on his face, and from the thick miasma of painted sparkles filling the surrounding air. Although this work might be read as an insight into the non-materialist roots of human happiness, it can as easily be understood as a comment on the blindness of the average passerby toward the inner radiance of society's more marginalized figures. A third Tomah-centered work, *Au bout du Fusil ~ Tomah* (1993), offers no such refuge in the overlay of subsidiary meanings. Squatting on the ground with his hands behind his back, a shirtless, blindfolded man patiently awaits his fate in front of a wall pocked by bullet holes. The claustrophobic desolation of this work, as well as its frank admission of our collective inability to help those who are in mortal peril, resonates profoundly in an age of increased 'ethnic cleansing' in such places as Bosnia and Rwanda. The possibility that the condemned man has actually committed some crime that would justify his execution seems beside the point, as our concern seems to be focused exclusively on the excruciating loneliness of the last moment of life.

Pierre et Gilles' repeated use of certain models also seems to have had a related impact on their choice of subject-matter. Polly, who appears as a nocturnal angel of death in the *Plaisirs de la Forêt* series, is also the subject of an unsettling work titled *Le Cauchemar de Pierrot ~ Polly* (1996). This tragicomic clown of French popular lore, whose appearance sometimes signals an entry into the realm of the melancholic, now appears as the victim of some terrifying fate. Framed by dense cobwebs and large, menacing spiders, Pierrot stares at us forlornly, a single tear trickling down his/her cheek. In their simple depiction of a beloved clown beset by nightmares, Pierre et Gilles seem also to refer somewhat obliquely to their own situation, and to the grim realization that even the giddiest escape artist faces the possibility of waking up in a world where all one's attempts at happiness are in danger of vanishing with the blink of an eye. A different but no less compelling image of melancholy pervades their work *Tentation ~ Jiro Sakamoto* (1999). An unusual work in light of its use of a non-referential background, *Tentation* owes its considerable power to the intensity of the expression in Jiro's

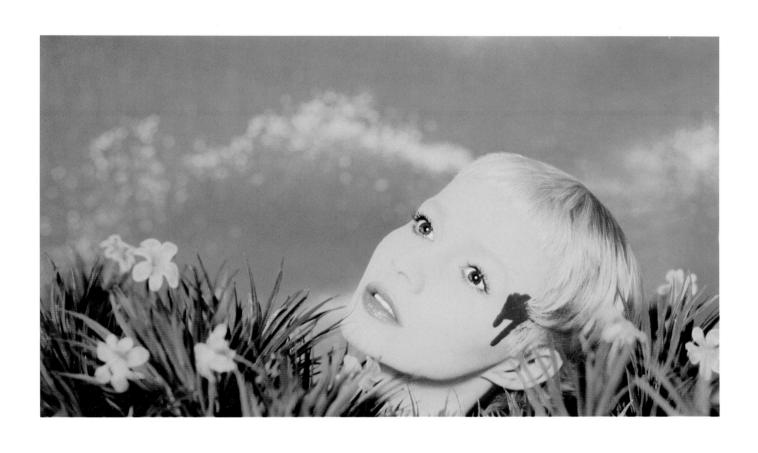

Catherine Blessée ~ Catherine Jourdan (1984)

sidelong stare. It is left unclear whether the title of the work refers to his being tempted by a person or event outside the frame, or if he is meant to personify the act of temptation. However it is understood by the viewer, *Tentation* seems to open up a new range of possibilities for Pierre et Gilles, in which their gift for creating illusion can be applied to the expression of deep emotion tempered by grace and subtlety.

SELF/IMAGE

Someday an entire exhibition will no doubt be organized around Pierre et Gilles' dozens of self-portraits, which cover nearly the entire breadth of their collaboration. While in many ways they are their own best subjects, it is difficult to see the evolution of these works as anything less than an extended meditation on themes of timelessness and beauty. As handsome young men in the midst of the Parisian fashion and music worlds of the 1980s, Pierre et Gilles tended to portray themselves as their own fantasy creations, dressing up like 1960s television detectives (*Les Pistolets ~ Pierre et Gilles*, 1987) or as Hindu versions of themselves (*Tamoul Mafia ~ Pierre et Gilles*, 1993). More recently, in synchronization with the growing complexity of the rest of their work, they have produced self-portraits that probe very different areas of the human psyche.

This exhibition includes a pair of recent self-portraits that at first study seem to be like nothing else in Pierre et Gilles' œuvre. Consisting of colorful racing helmets balanced on sweeping black cloaks, the helmets' portals are also blacked out, so that it is impossible to determine whether or not the artists' faces are hidden somewhere inside. While winged skulls hover around their heads, licks of red flame fill the pictures' lower foreground. Clearly a species of *memento mori*, these *Autoportraits sans Visage* (1999) present the inevitability of death as a kind of ongoing creative challenge. The darkened helmets appear to signify the disappearance of the artists as mortal beings, but they could also be seen as clever attempts to outwit death. If the helmets, which in more orthodox contexts protect their wearers from injuries to the head, are

Tamoul Mafia ~ Pierre (1993)

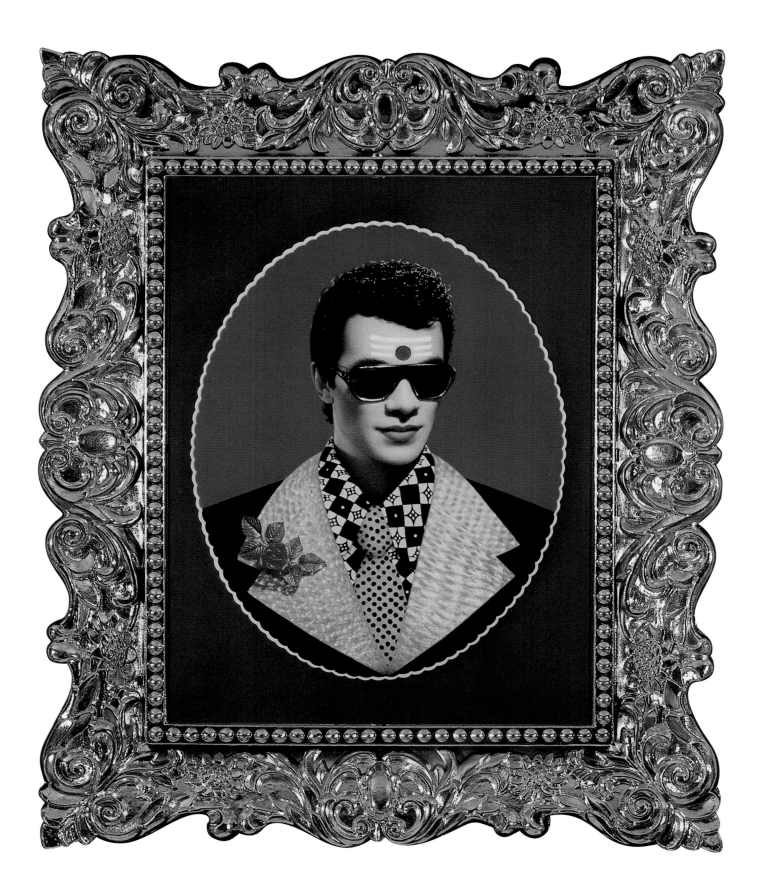

in fact empty, then the possibility exists that death will pass on, suggesting a very different form of protection. These works also illustrate a peculiar quandary faced by all artists who confront both the artistic challenges implicit in the daunting task of representation, and a dual role as observers and interpreters of an epoch. Since Pierre et Gilles have never attempted to disguise the subjectivity of their own position as artists, perhaps these works should be understood as attempts to confront their fate, even laugh at it. After all, the courage required to sustain their unique investigation through the past quarter-century has carried them through a remarkable array of disguises, fantasies, desires, and beliefs, and each time they have gone to extraordinary lengths to demonstrate that the boundaries of lived reality are nothing more or less than the limits of our imagination. For them to have gone this far without also transforming the inevitability of death into an idea about life would not merely seem wildly out of character; it would also contradict one of the fundamental beliefs underlying Pierre et Gilles' art, which is that the most difficult but important challenge of our creative lives is how to transform our most deeply held desires into a tangible reality that offers others, in turn, the freedom to become more alive than they ever thought possible.

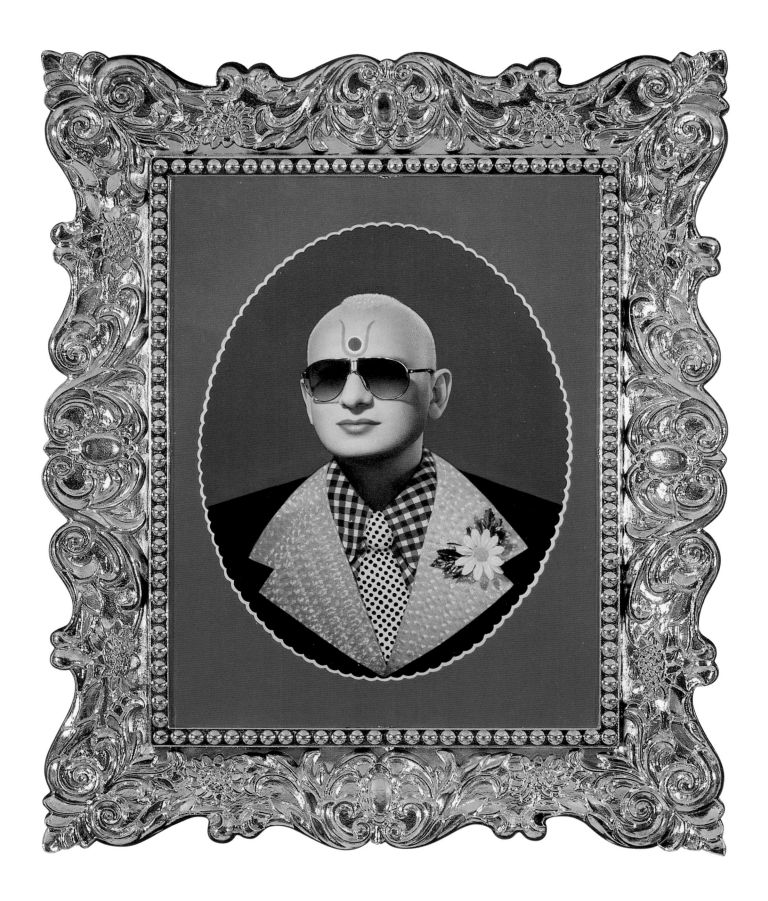

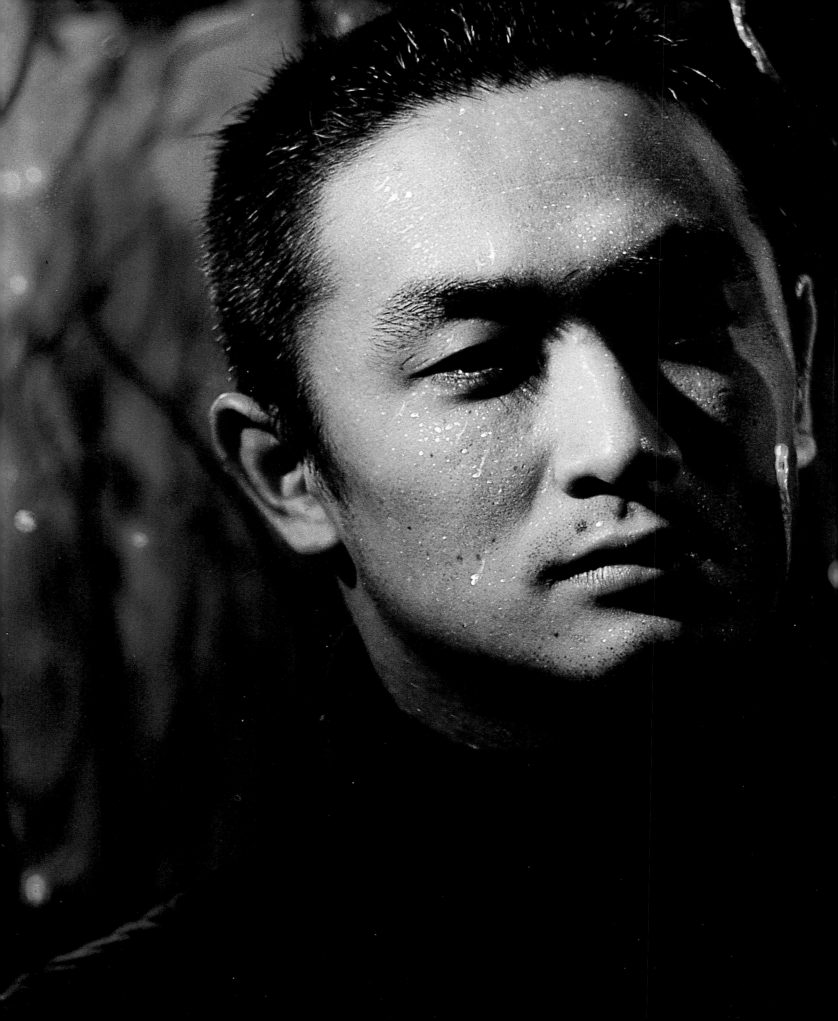

The Idiot ~ Iggy Pop, 1977

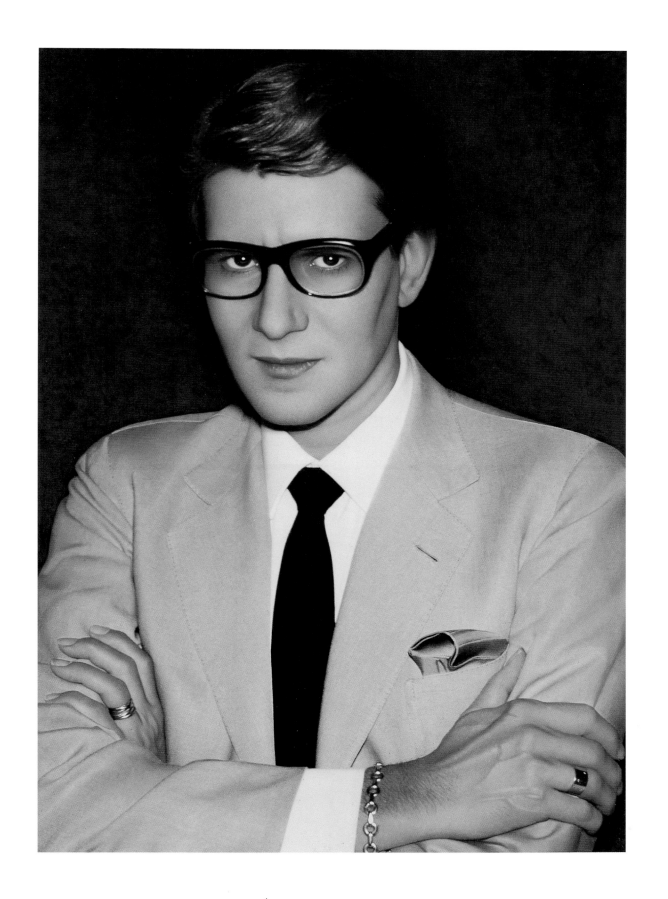

Yves Saint-Laurent, 1978

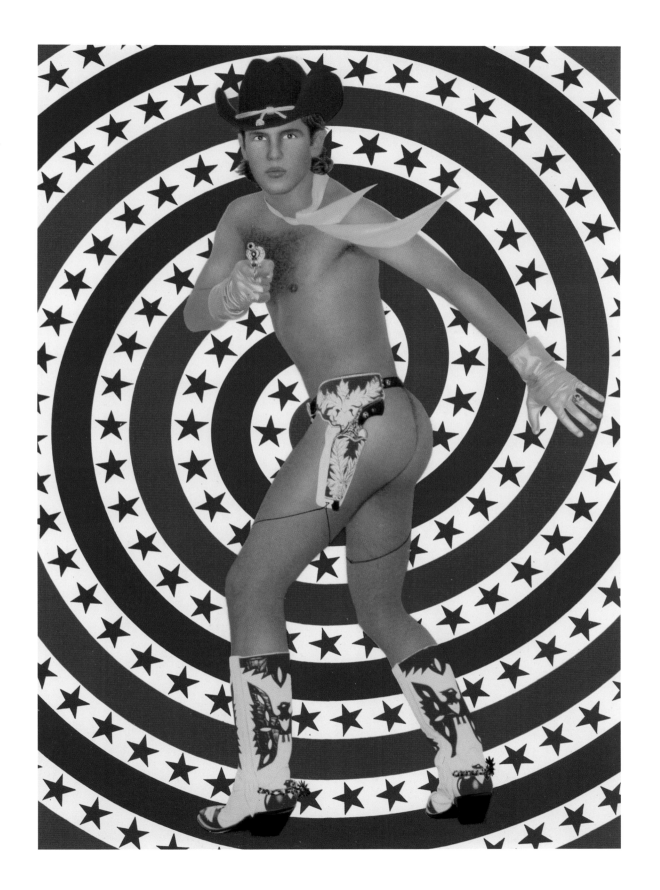

Le Cow-boy ~ Victor, 1978

Arja, 1979

Krootchey, 1980

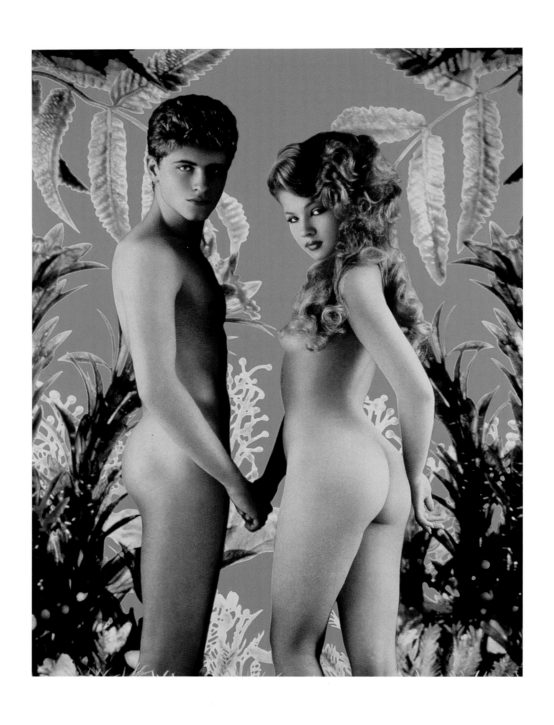

Adam et Eve ~ Eva Ionesco & Kevin Luzac, 1981

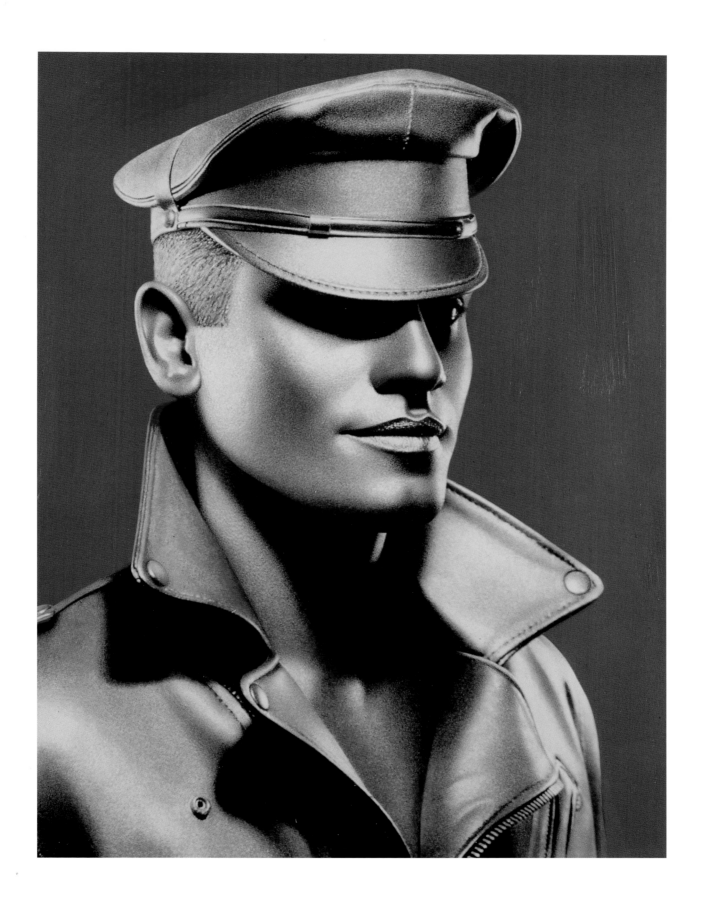

Silver Biker ~ David Pontremoli, 1982

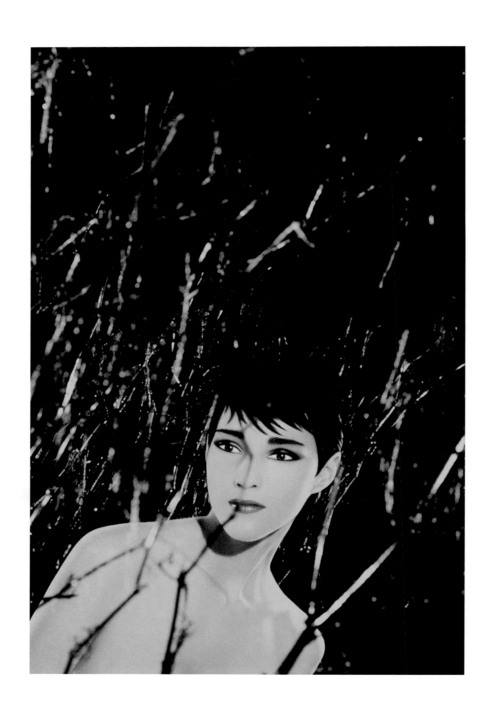

Dovanna, 1983

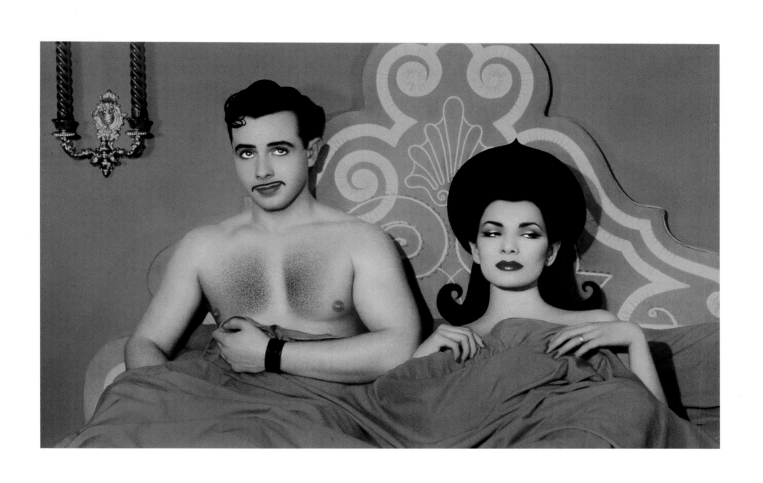

La Panne ~ Patrick Sarfati & Ruth Gallardo, 1983

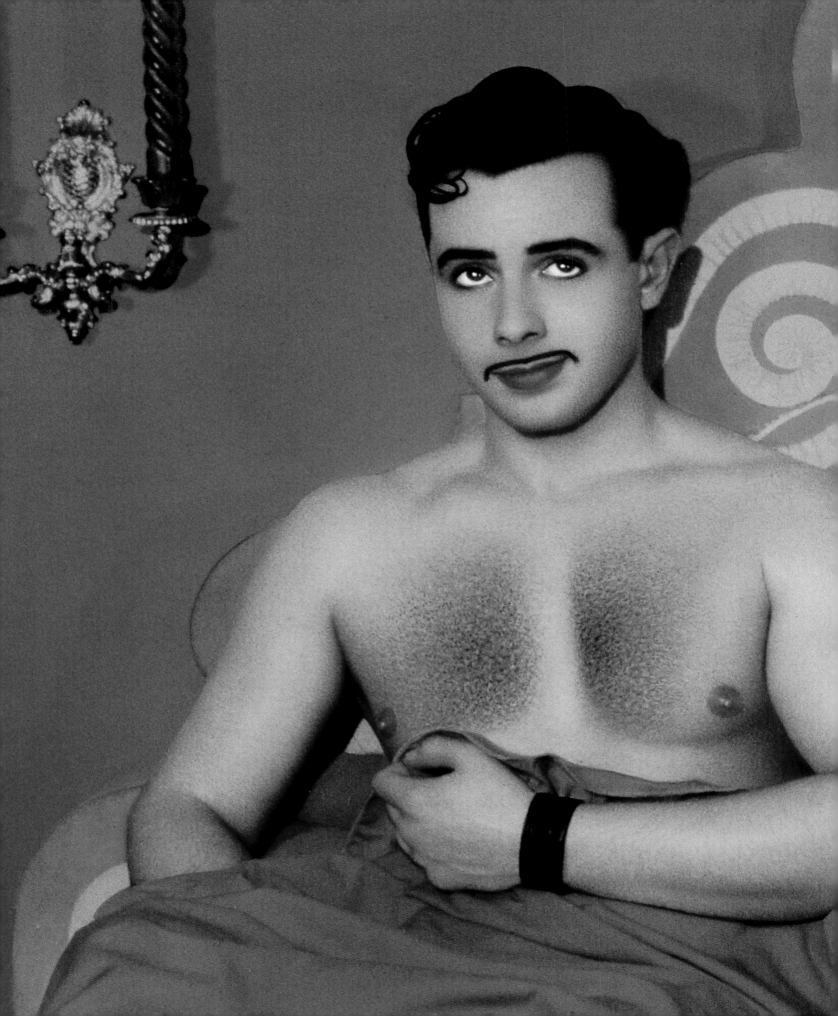

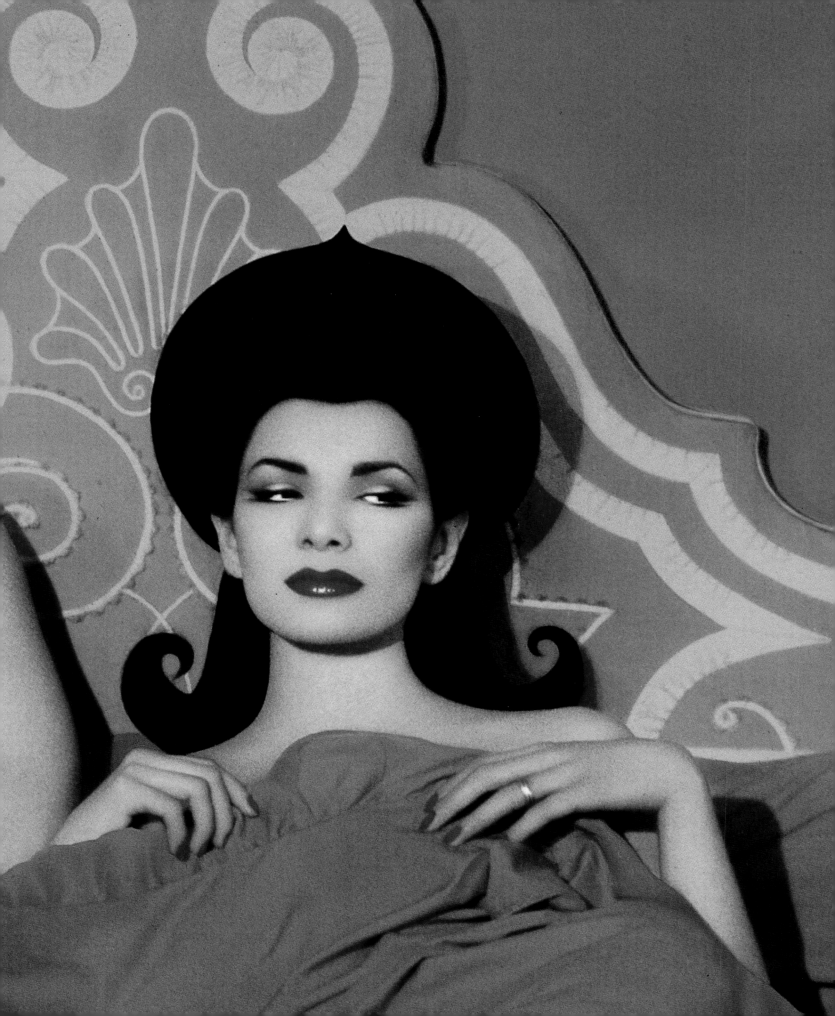

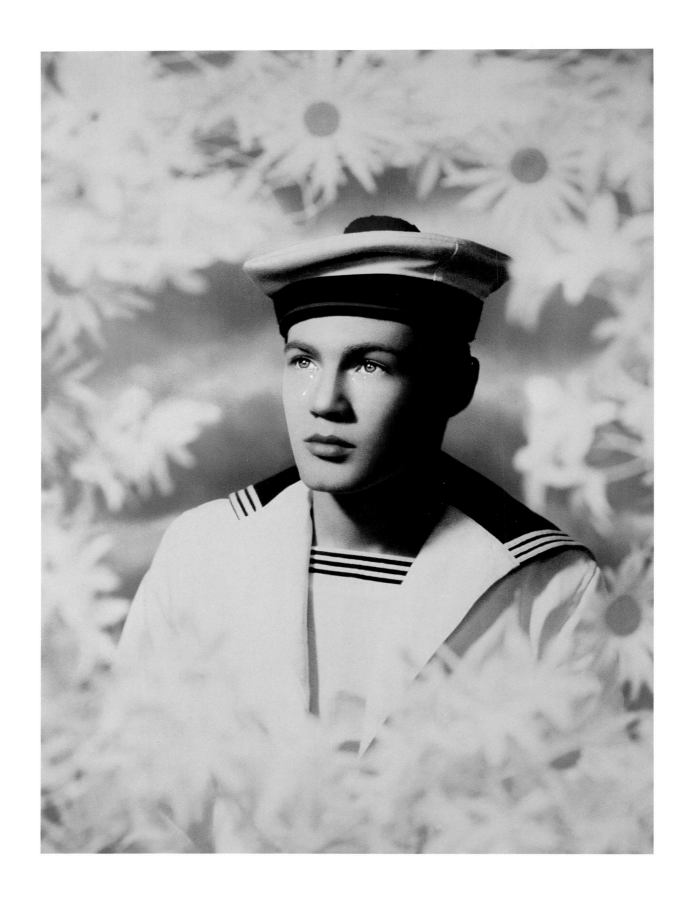

Le Marin ~ Philippe Gaillon, 1985

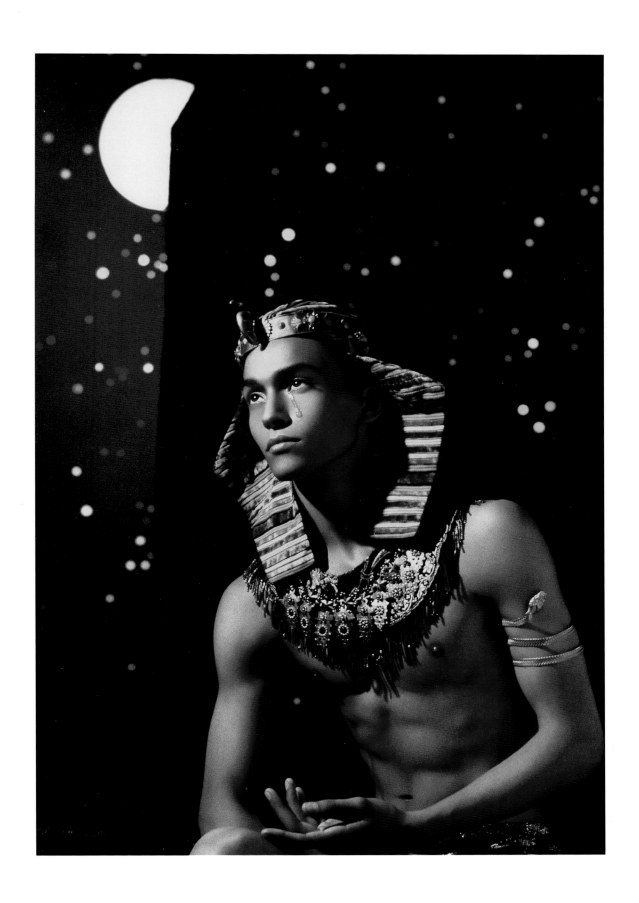

Le Jeune Pharaon ~ Hamid, 1985

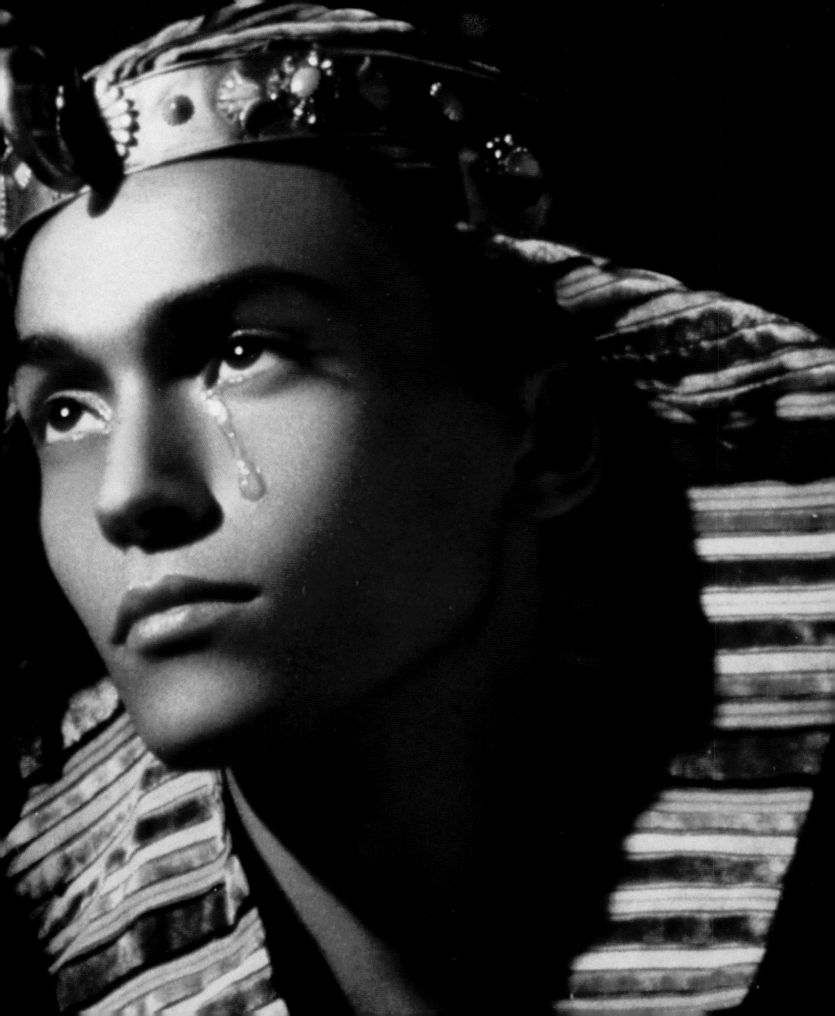

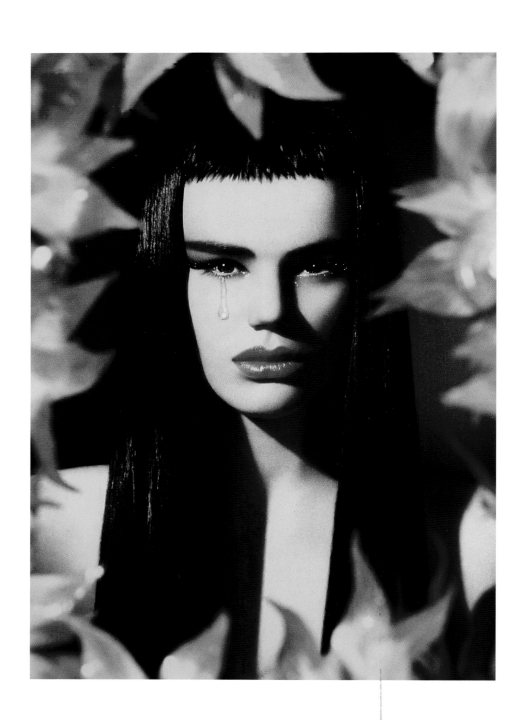

Pleureuse ~ Claire Nebout, 1986

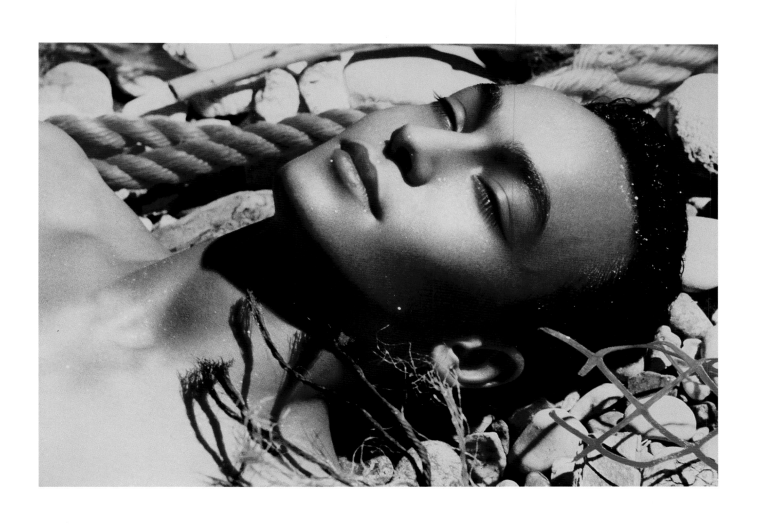

Naufragé ~ Hamid, 1985

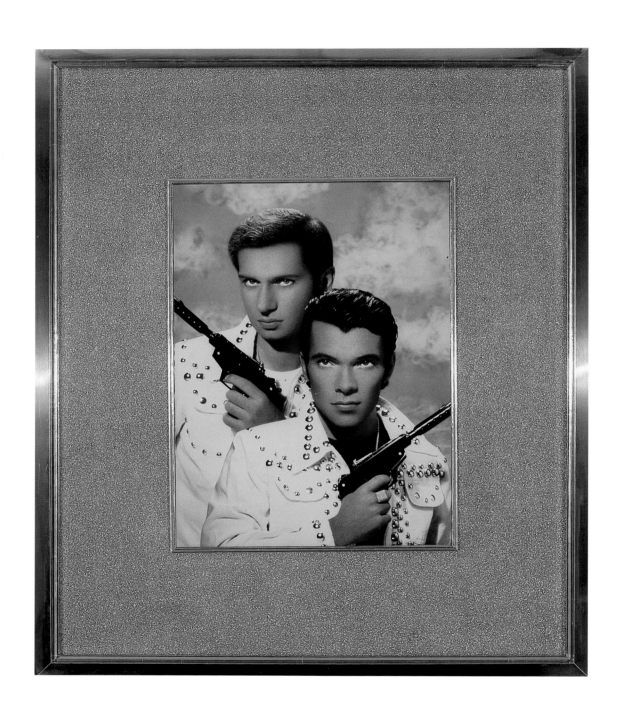

Les Pistolets ~ Pierre et Gilles, 1987

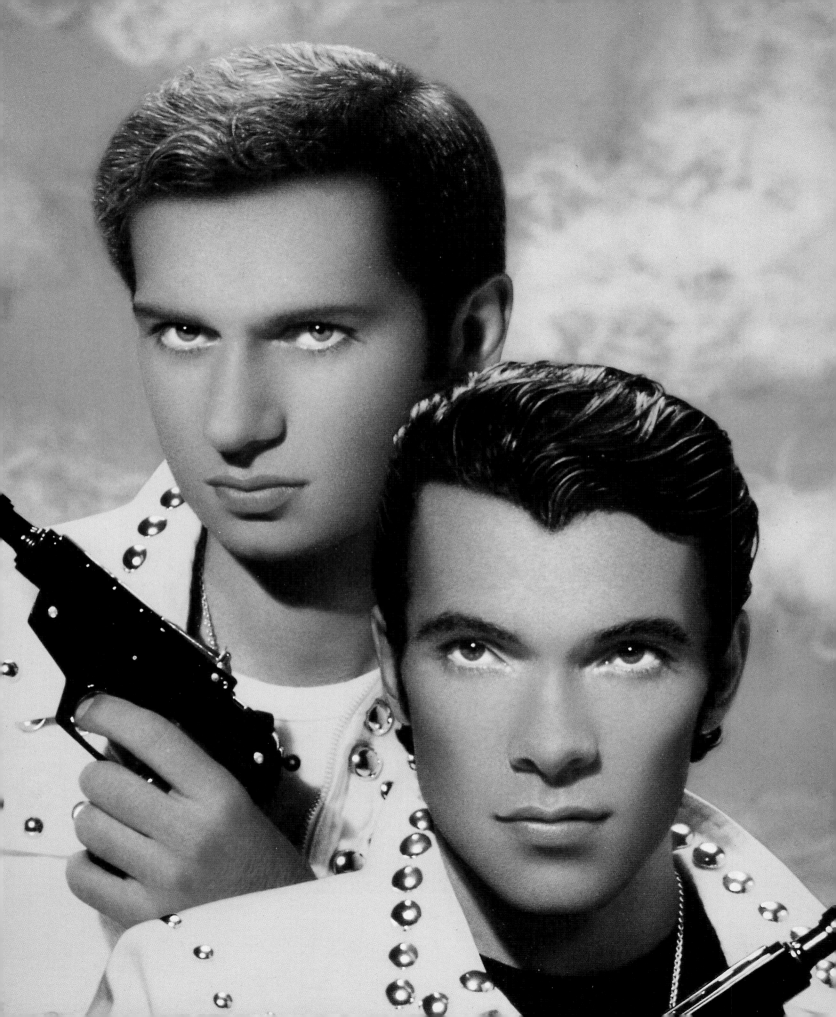

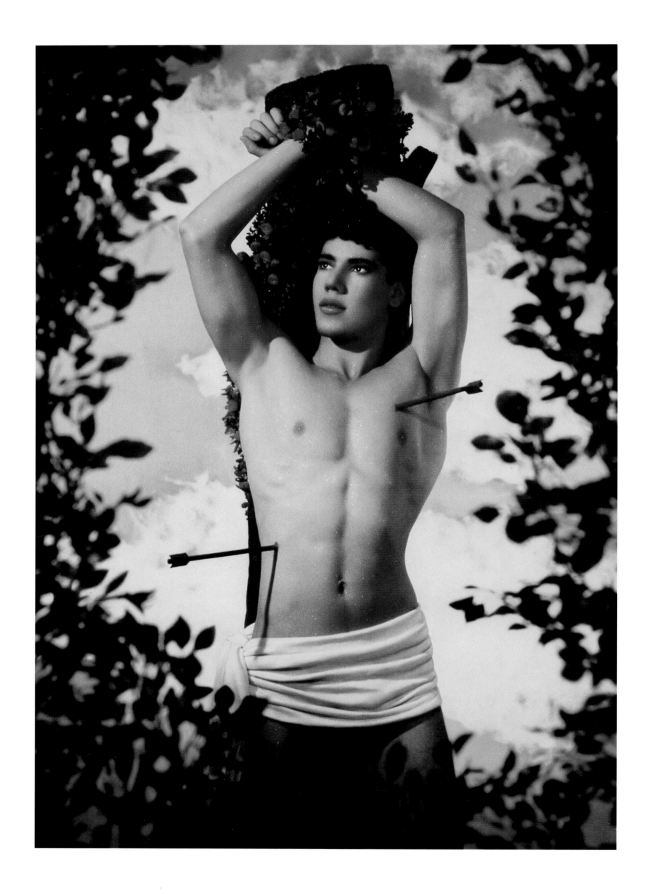

Saint Sébastien ~ Bouabdallah Benkamla, 1987

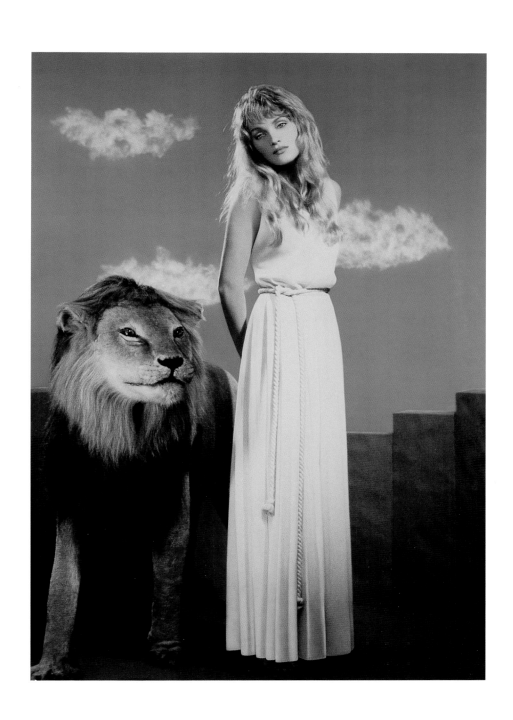

Sainte Blandine ~ Arielle Dombasle, 1988

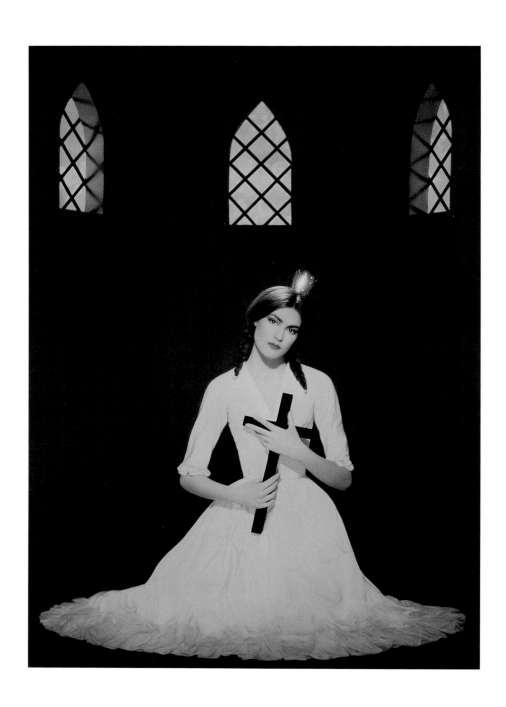

Sainte Barbe ~ Roussia, 1989

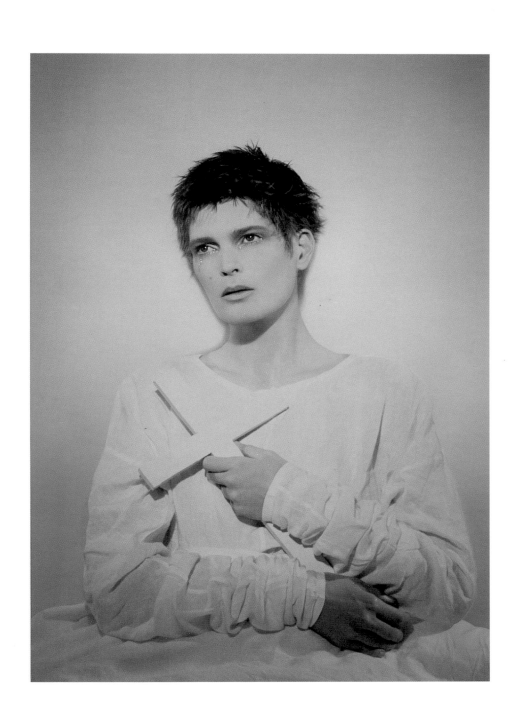

Sainte Lydwine de Schiedam ~ Leslie Winner, 1989

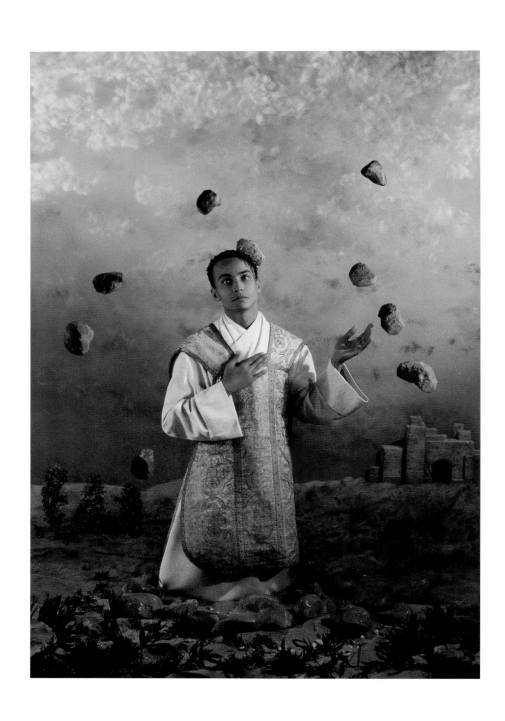

Saint Etienne ~ Hamid, 1991

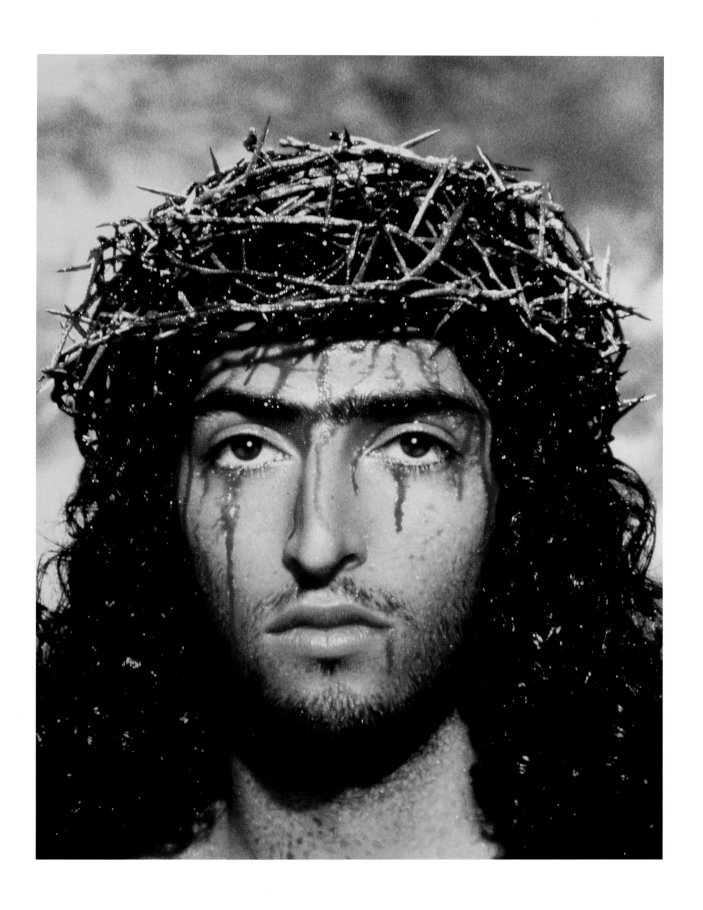

Jésus Christ ~ Philippe Bialobos, 1988

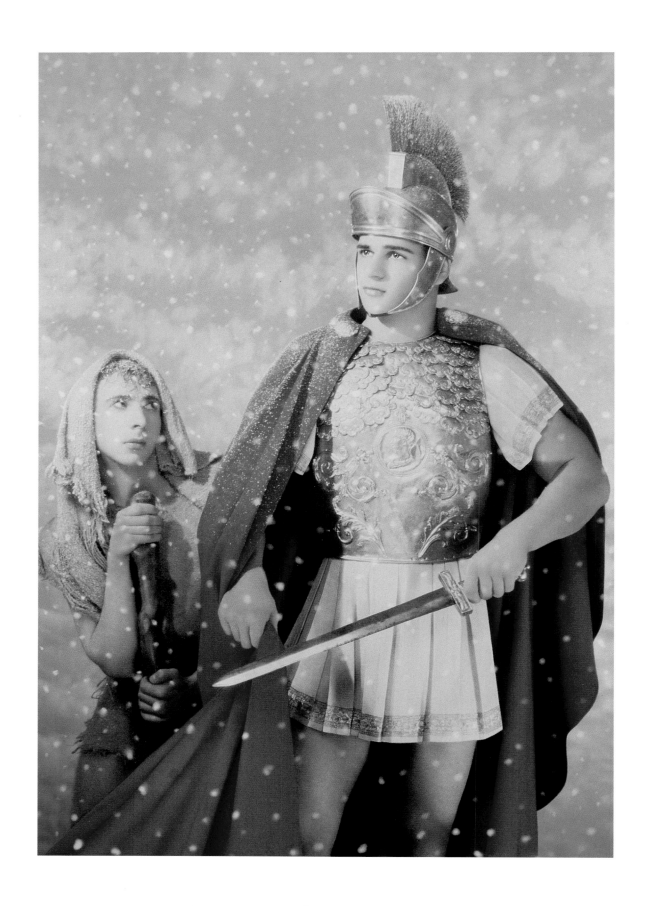

Saint Martin ~ Marc Almond and Karim Boualam, 1989

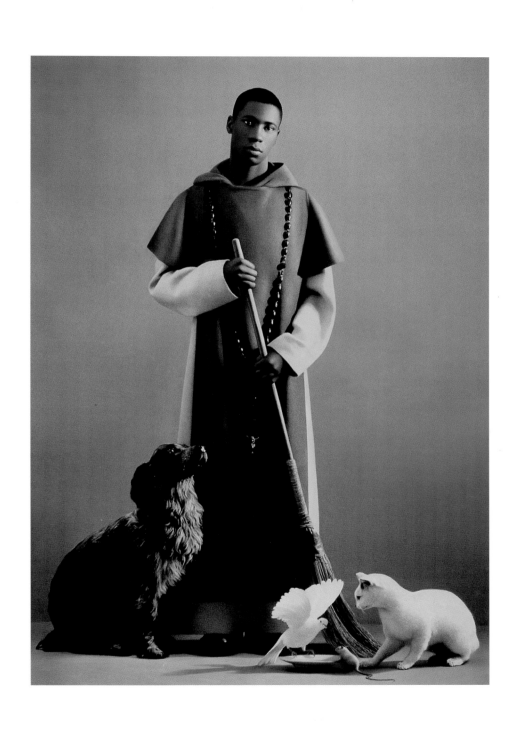

Saint Martin de Porres ~ Carlos, 1990

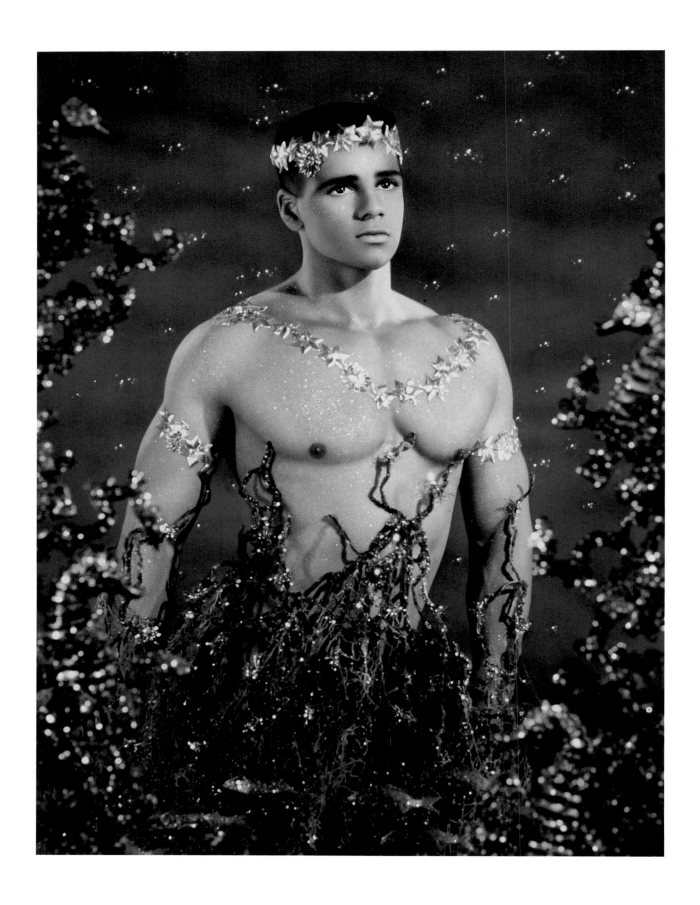

Neptune ~ Karim, 1988

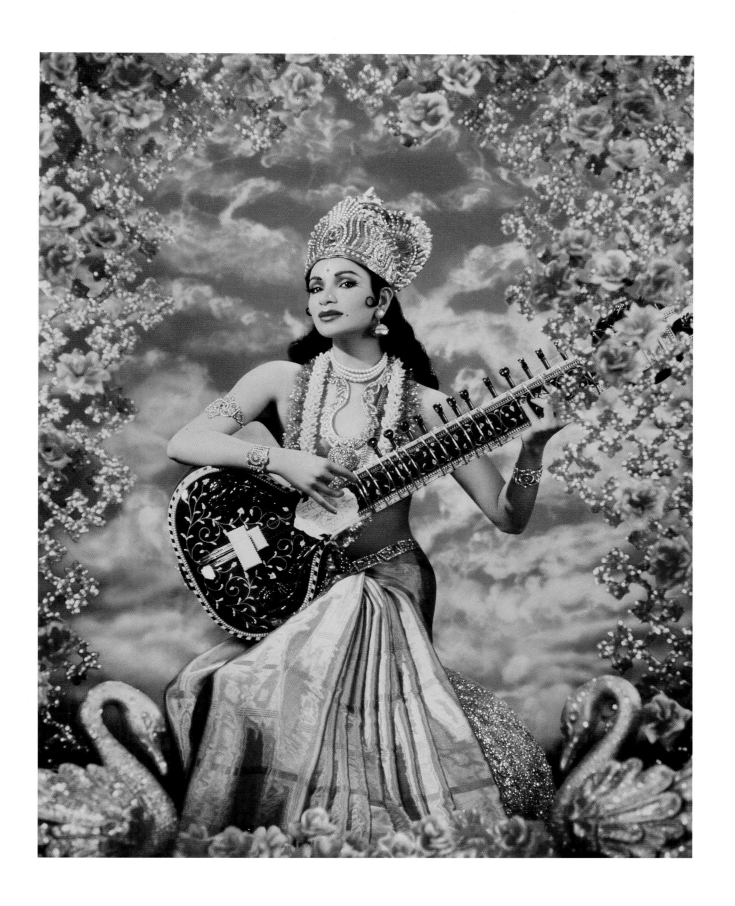

Sarasvati ~ Ruth Gallardo, 1988

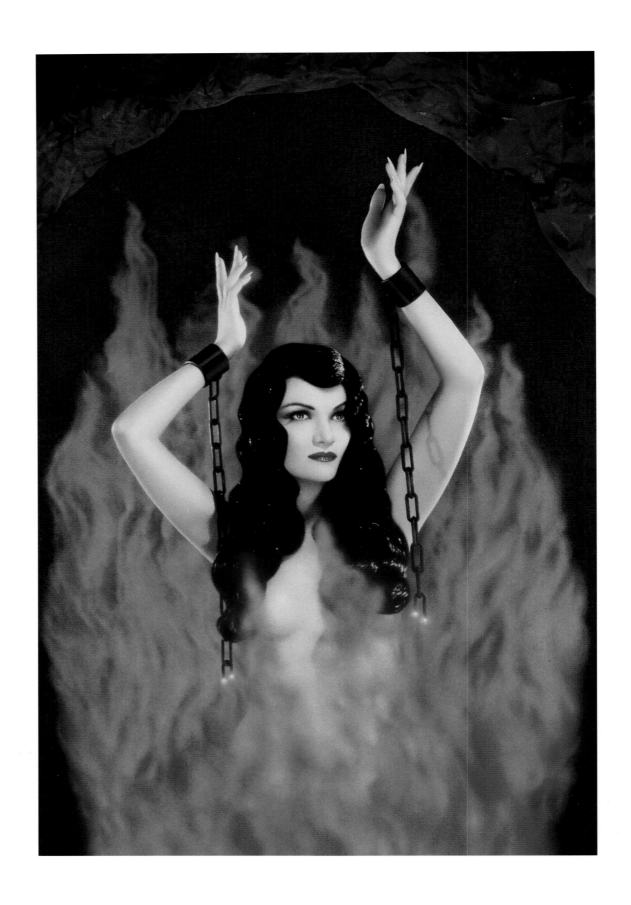

Le Purgatoire ~ Marie-France, 1990

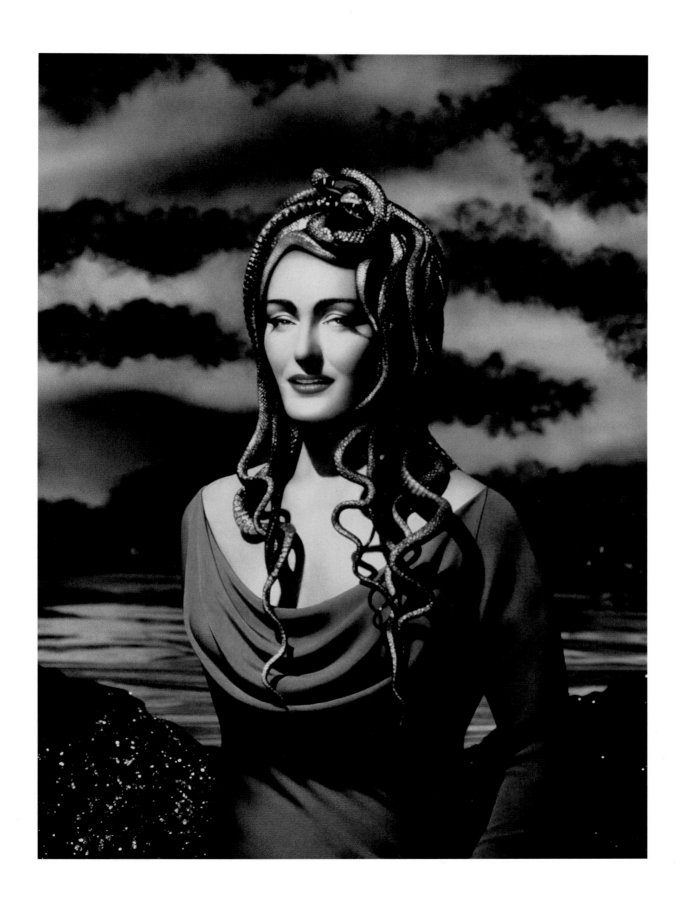

Méduse ~ Zuleika, 1990

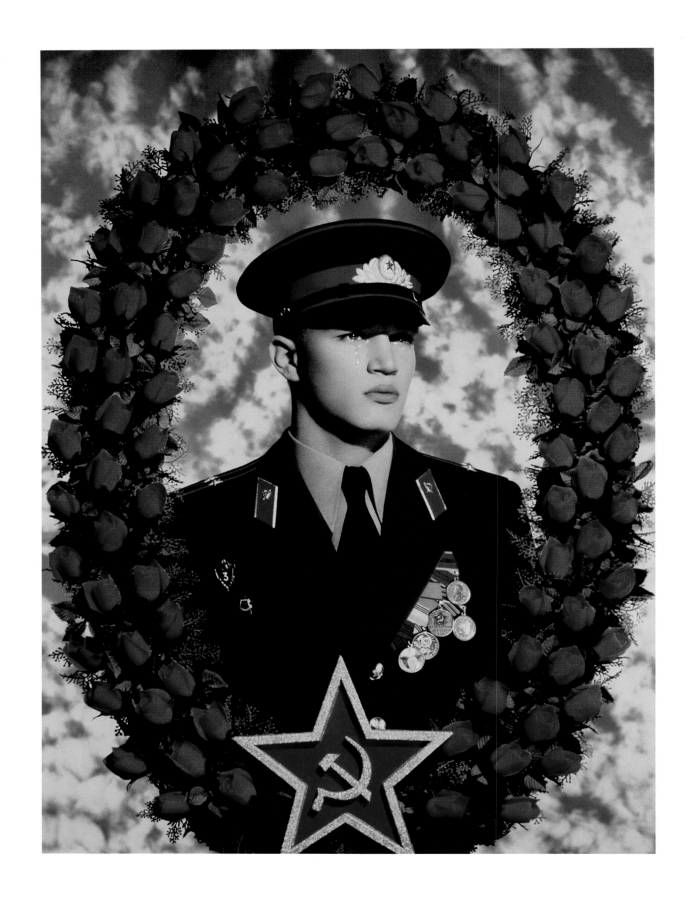

Le Petit Communiste ~ Christophe, 1990

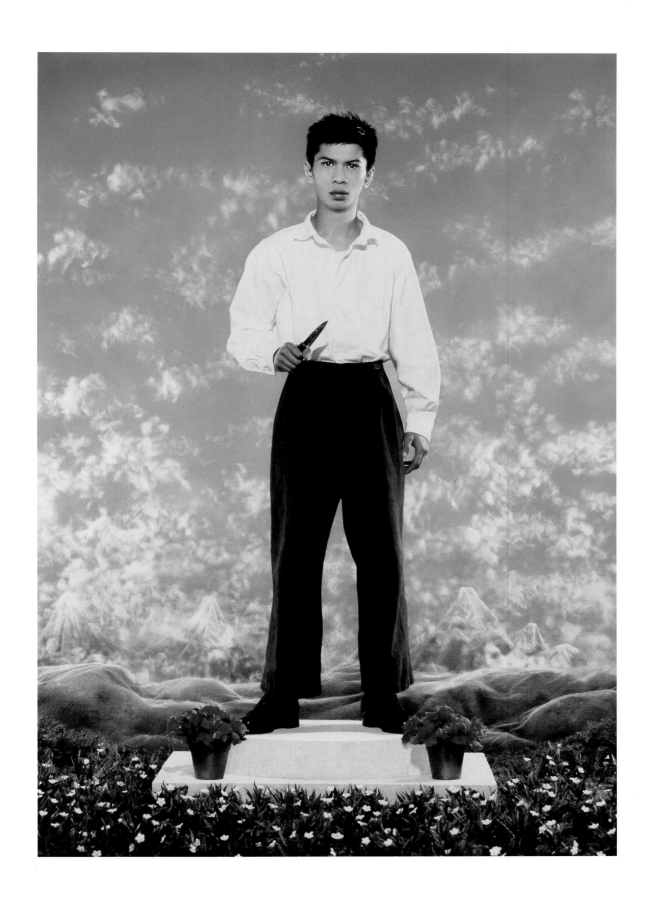

Le Petit Chinois ~ Tomah, 1991

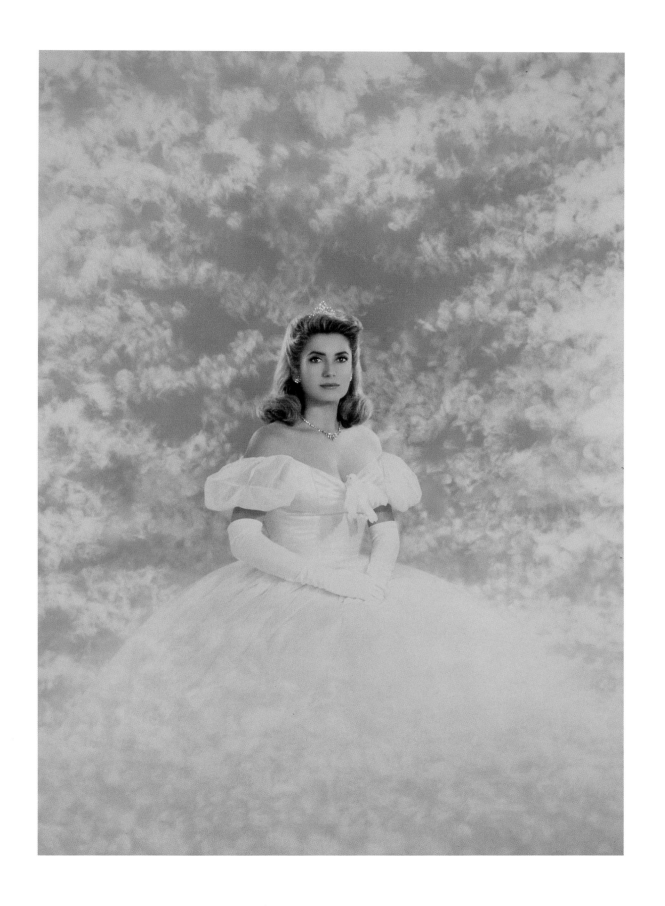

La Reine Blanche ~ Catherine Deneuve, 1991

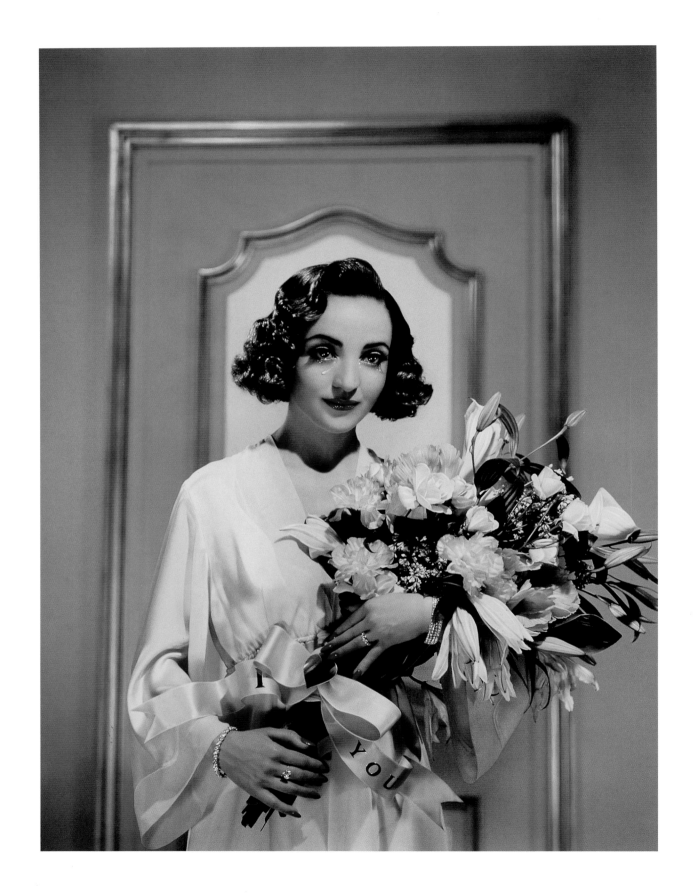

I Love You ~ Dominique Blanc, 1992

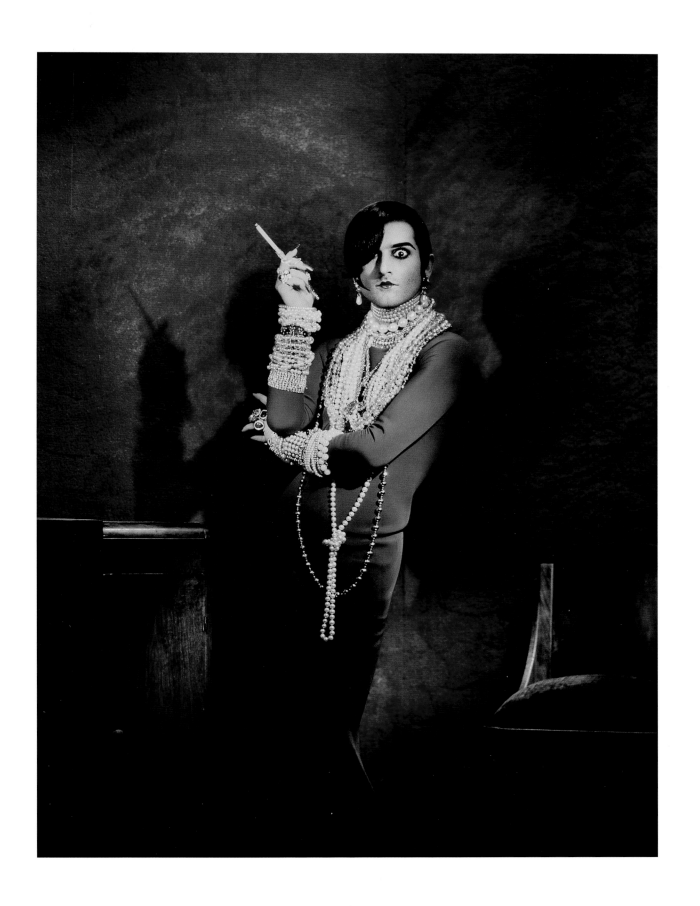

Eliane Pine Caringhton ~ Elian, 1992

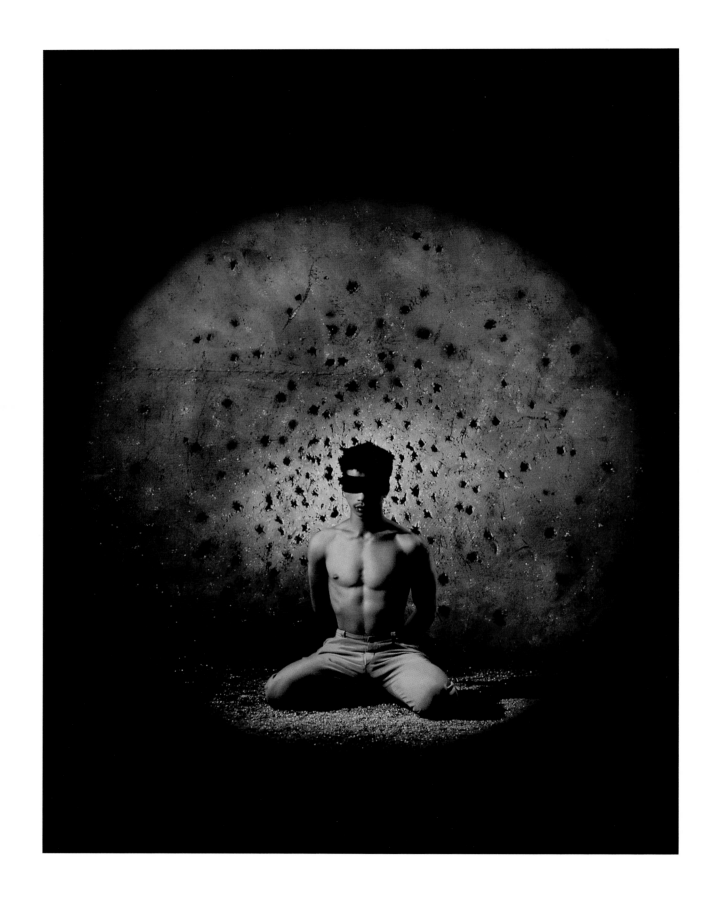

Au bout du Fusil ~ Tomah, 1993

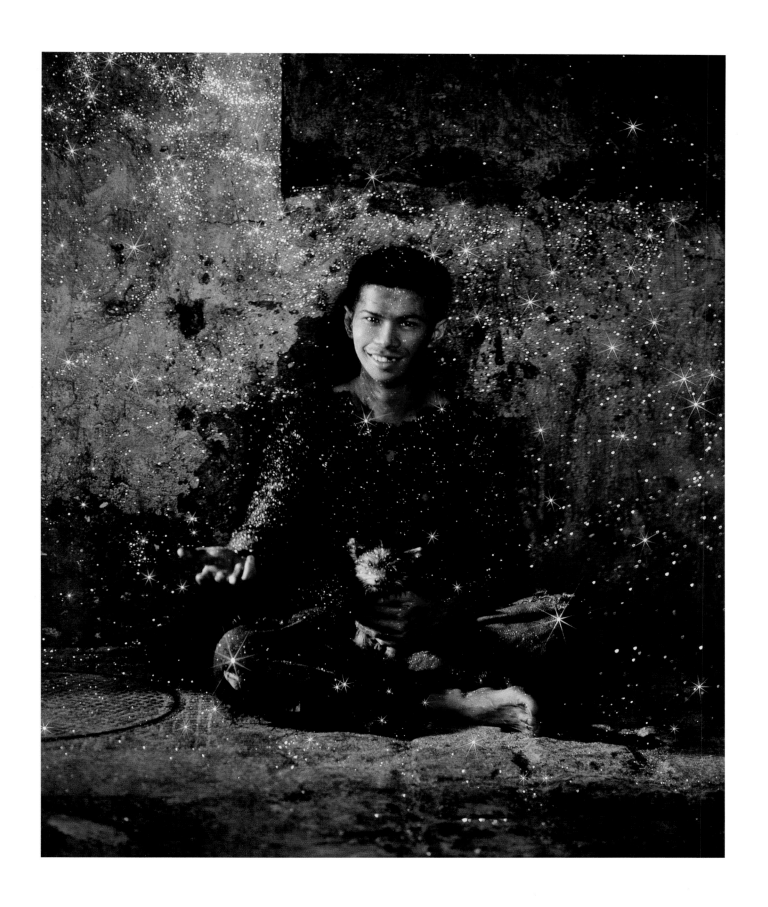

Le Petit Mendiant ~ Tomah, 1992

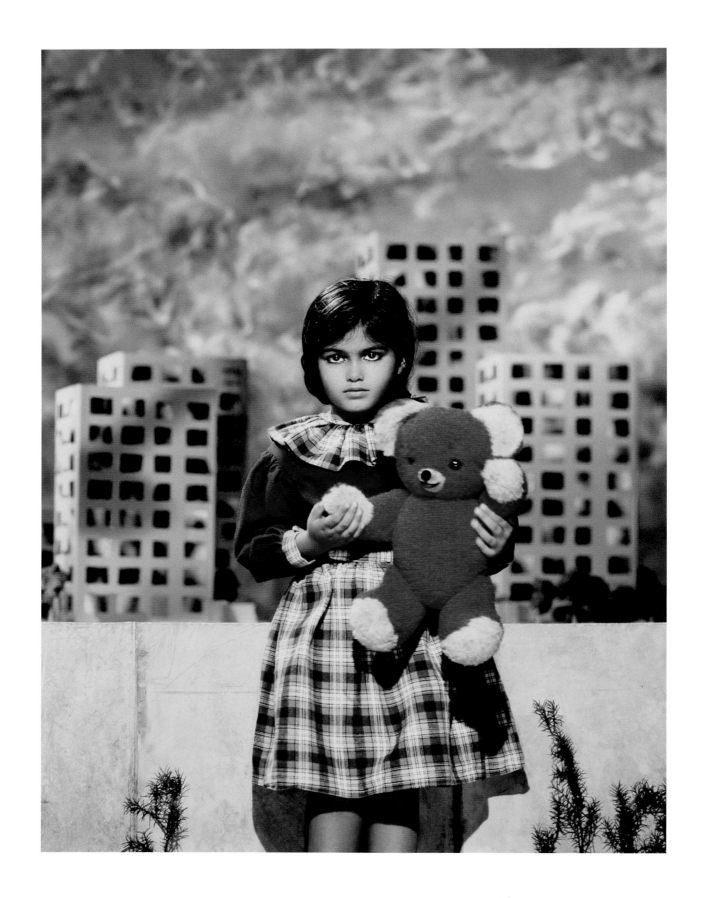

La Petit Fille des H.L.M. ~ Soraya, 1992

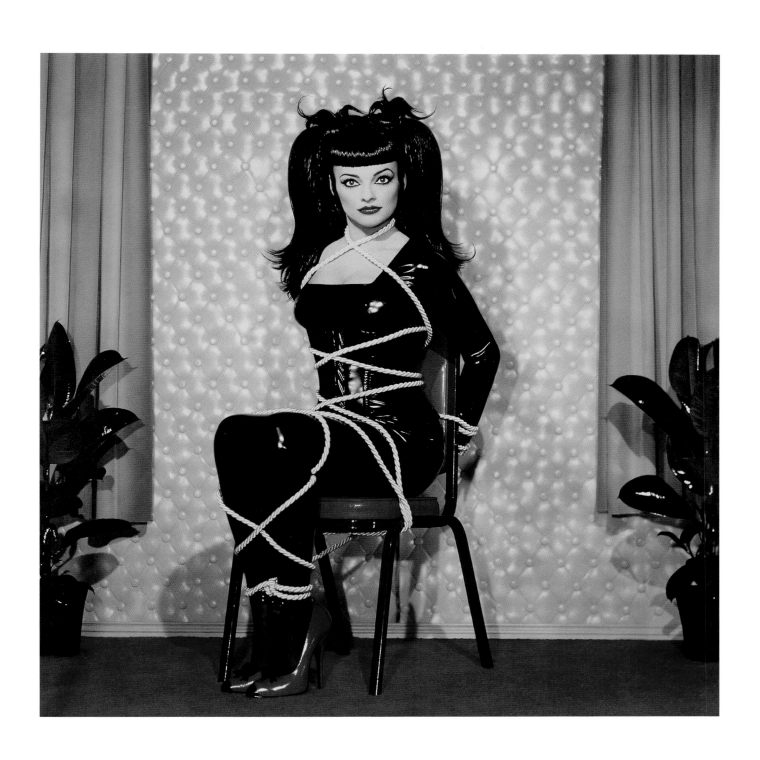

Nina Hagen, 1993

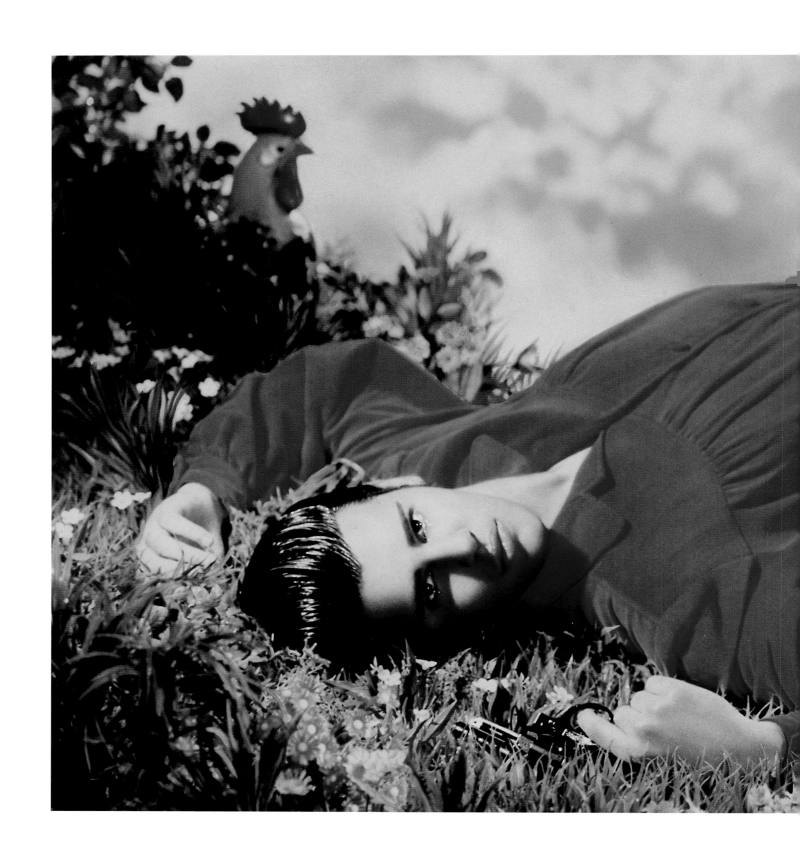

Elvis My Love ~ Stavros, 1994

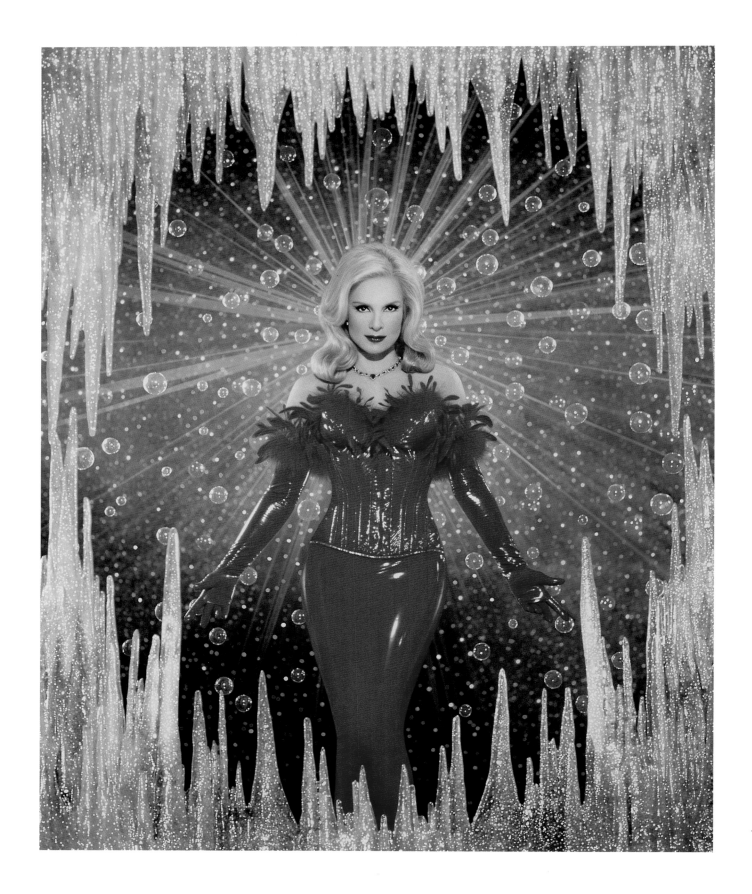

Ice Lady ~ Sylvie Vartan, 1994

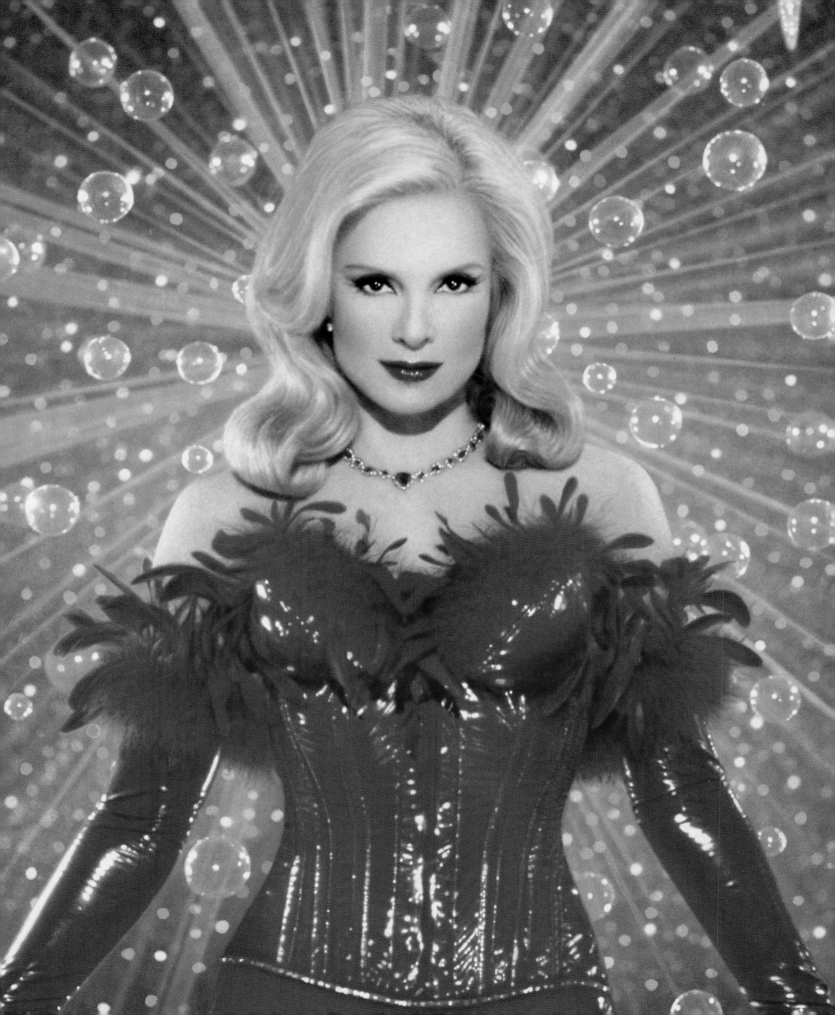

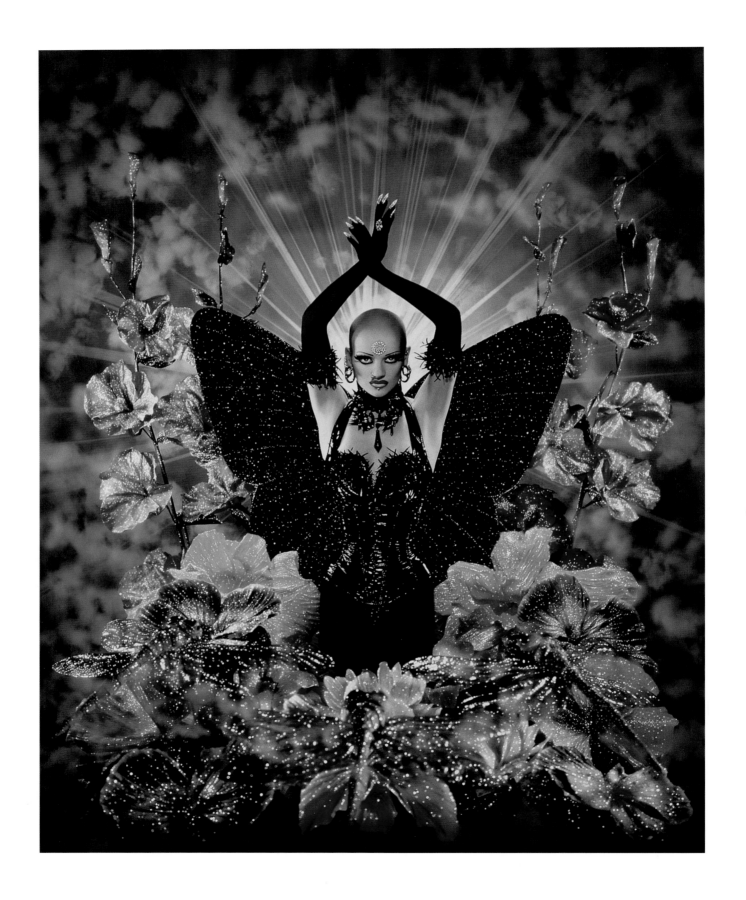

Le Papillon Noir ~ Polly, 1995

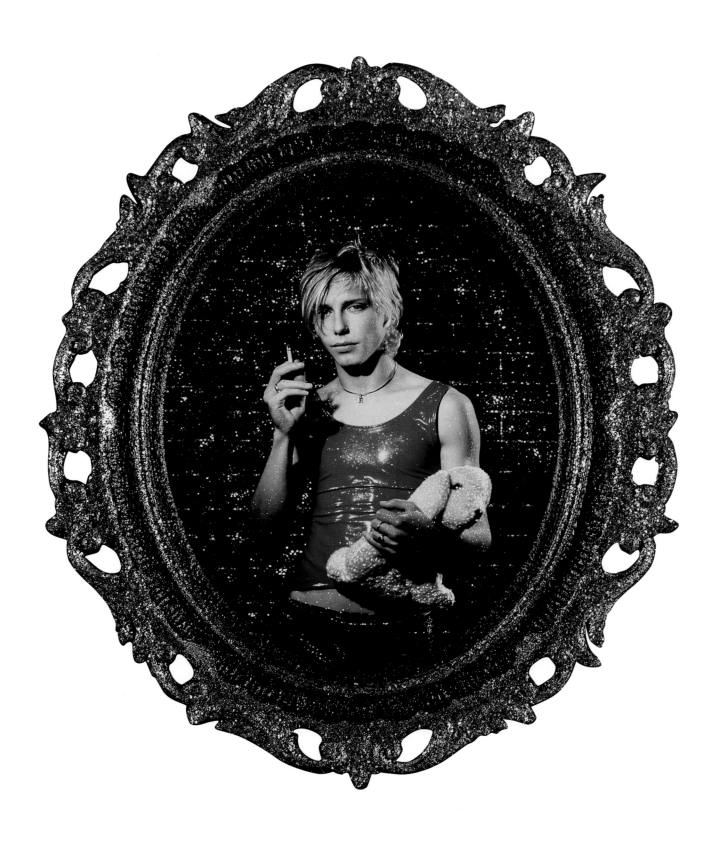

Joli Voyou ~ Eric, 1995

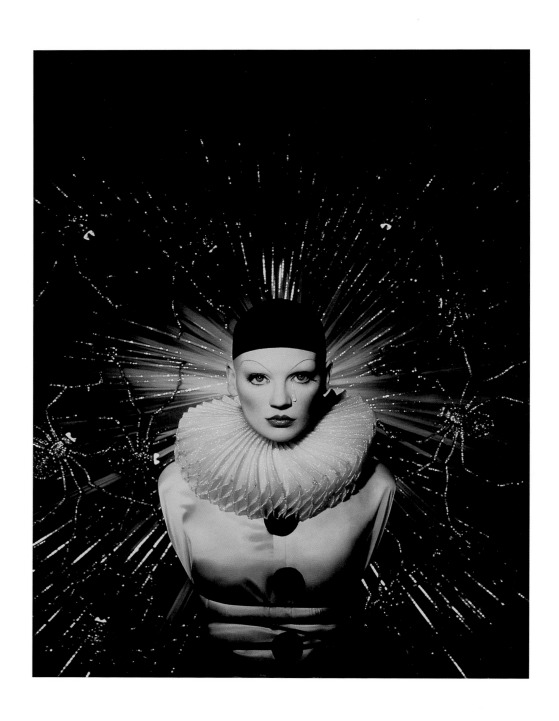

Le Cauchemar de Pierrot ~ Polly, 1996

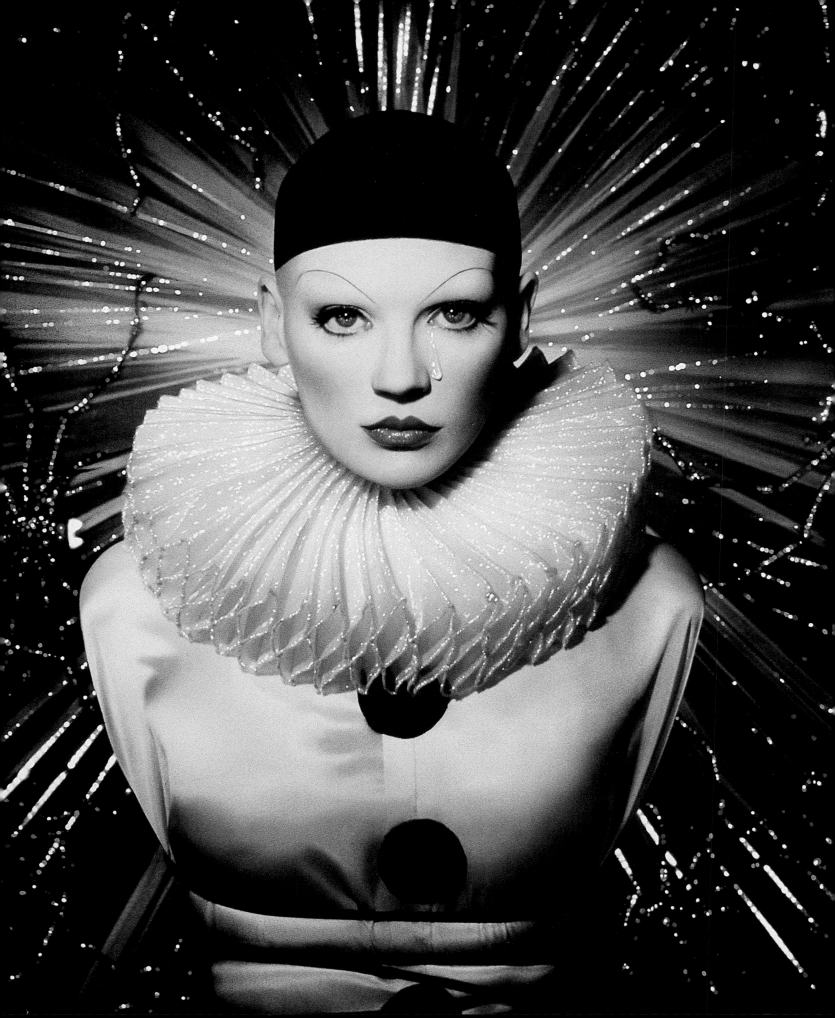

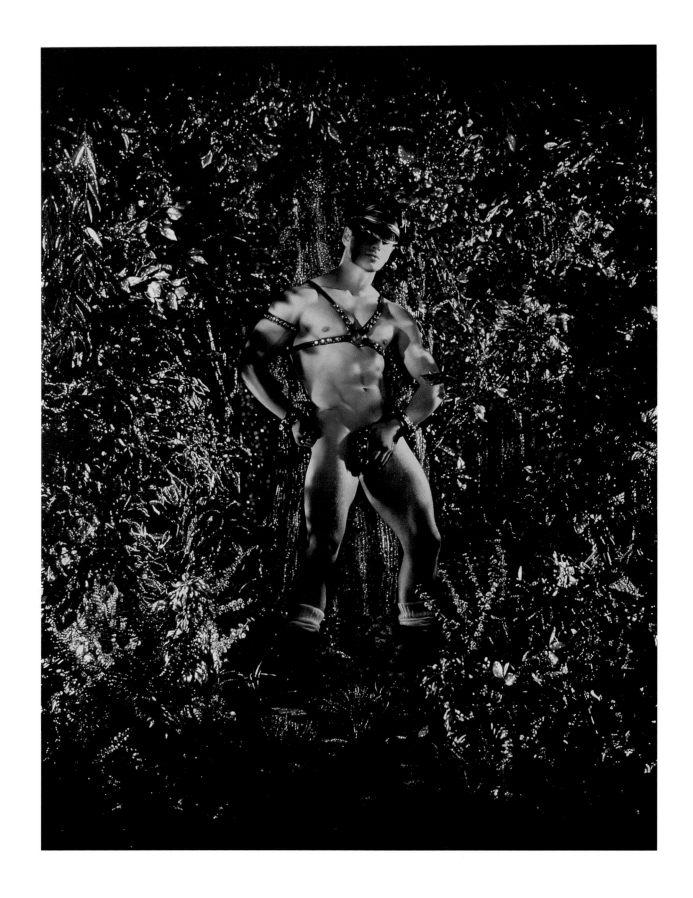

Les Plaisirs de la Forêt ~ Marc Anthony, 1995

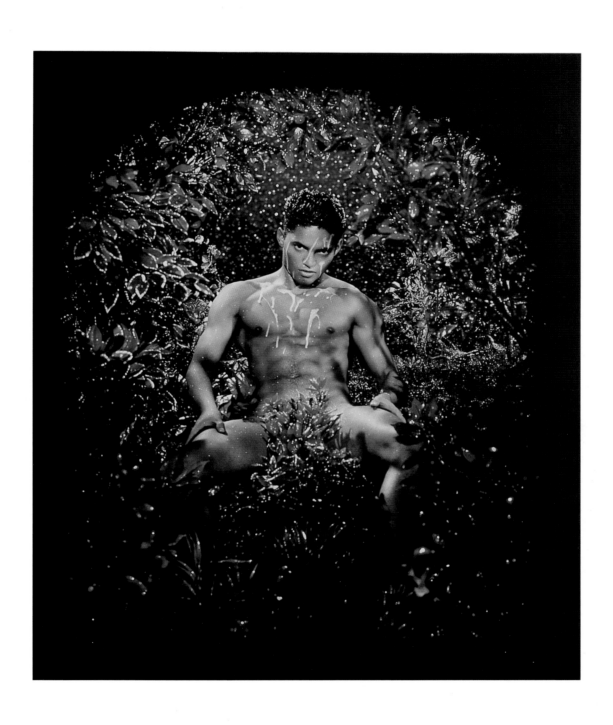

Les Plaisirs de la Forêt ~ Johnny, 1996

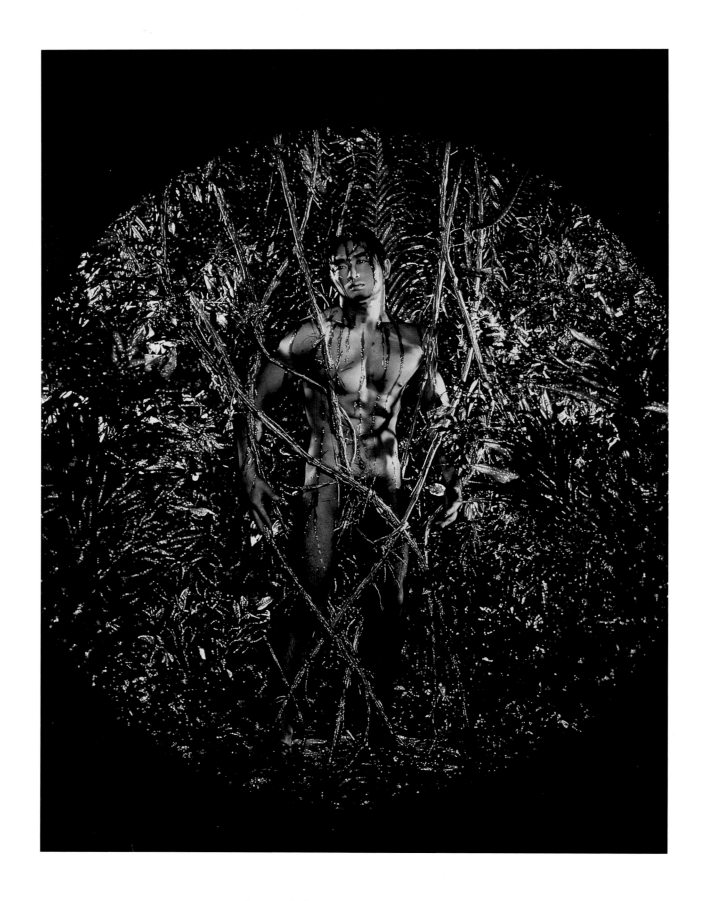

Les Plaisirs de la Forêt ~ Jiro Sakamoto, 1996

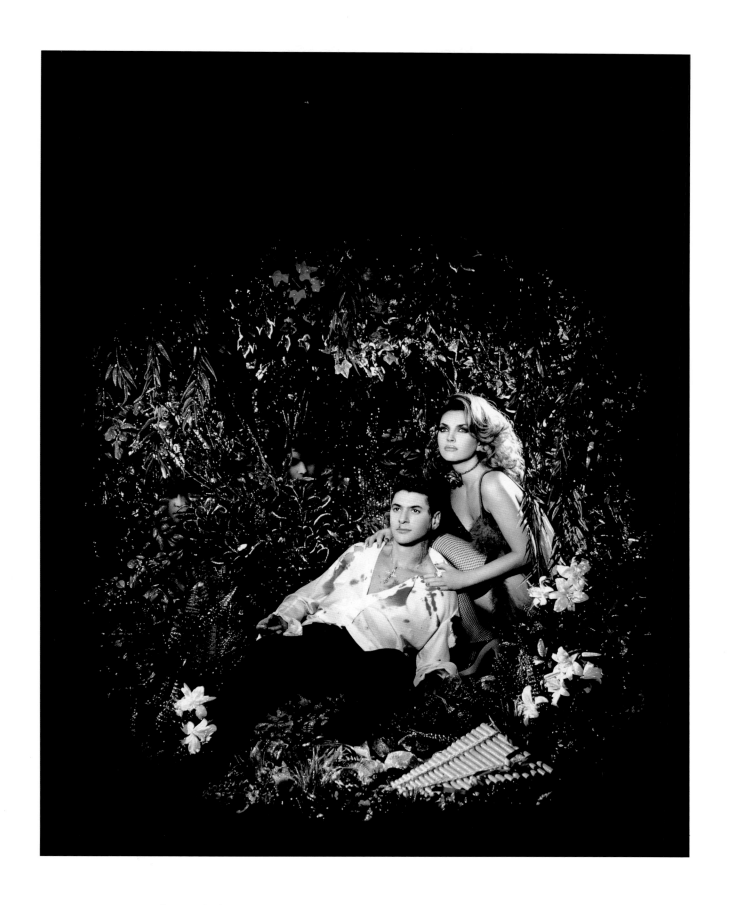

Les Plaisirs de la Forêt ~ *Etienne Daho, Sarah Cracknell, Bob and Pete, 1996*

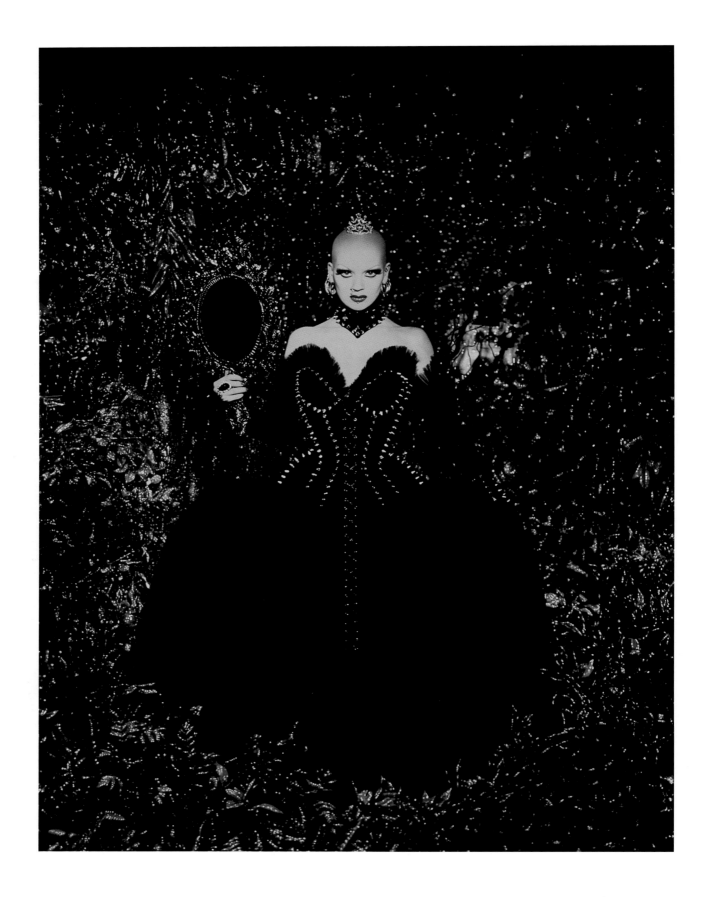

Les Plaisirs de la Forêt ~ Polly, 1996

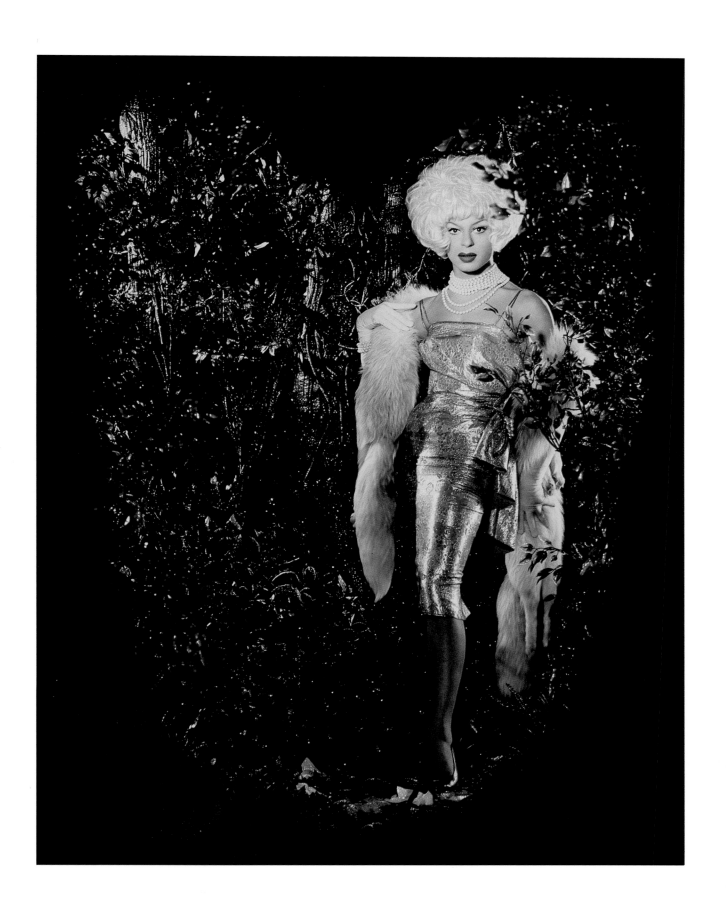

Les Plaisirs de la Forêt ~ Lola, 1996

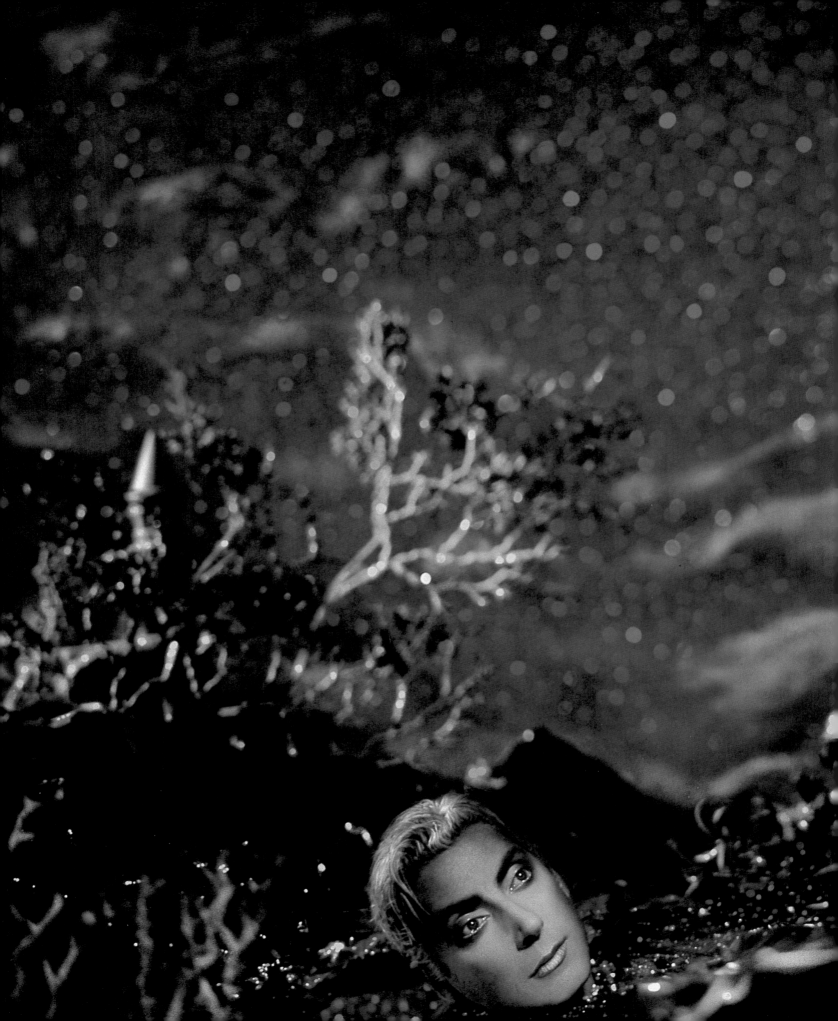

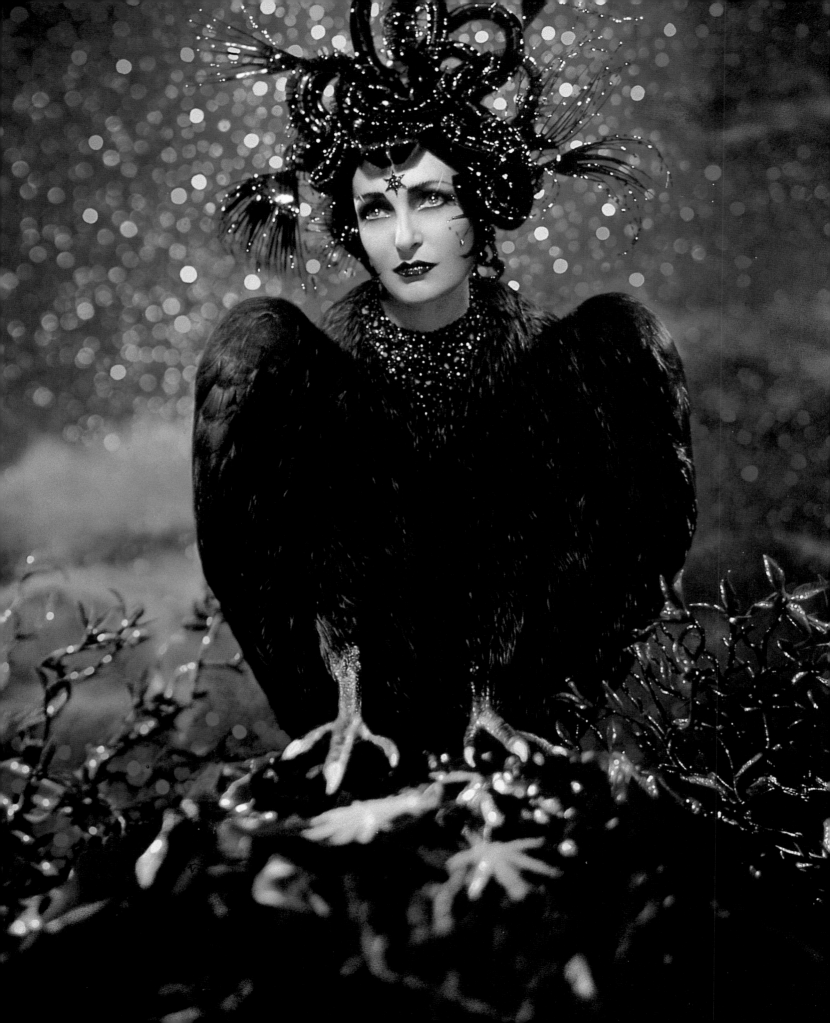

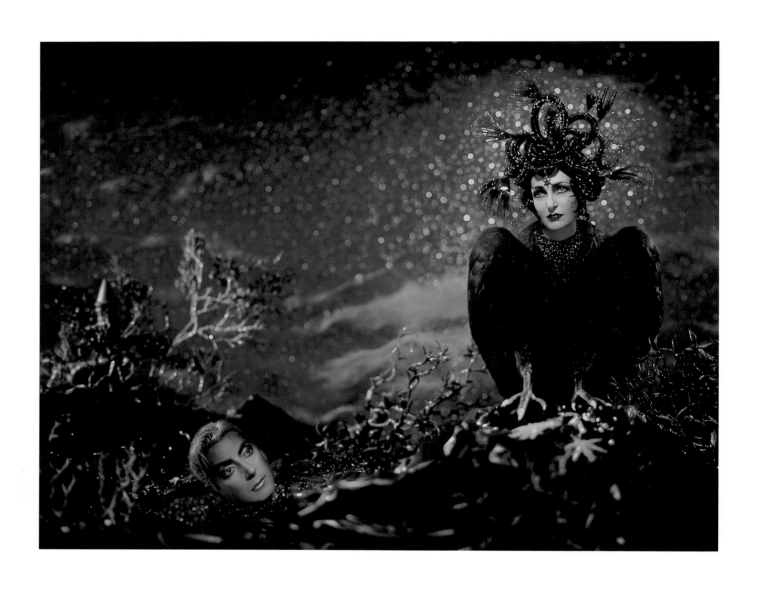

Créatures ~ Siouxsie Sioux & Budgie, 1997

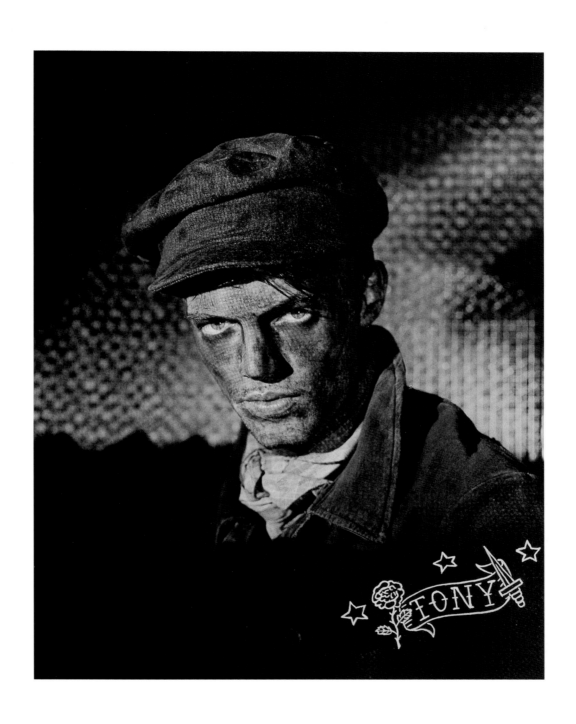

La Rose et Le Couteau ~ Tony, 1998

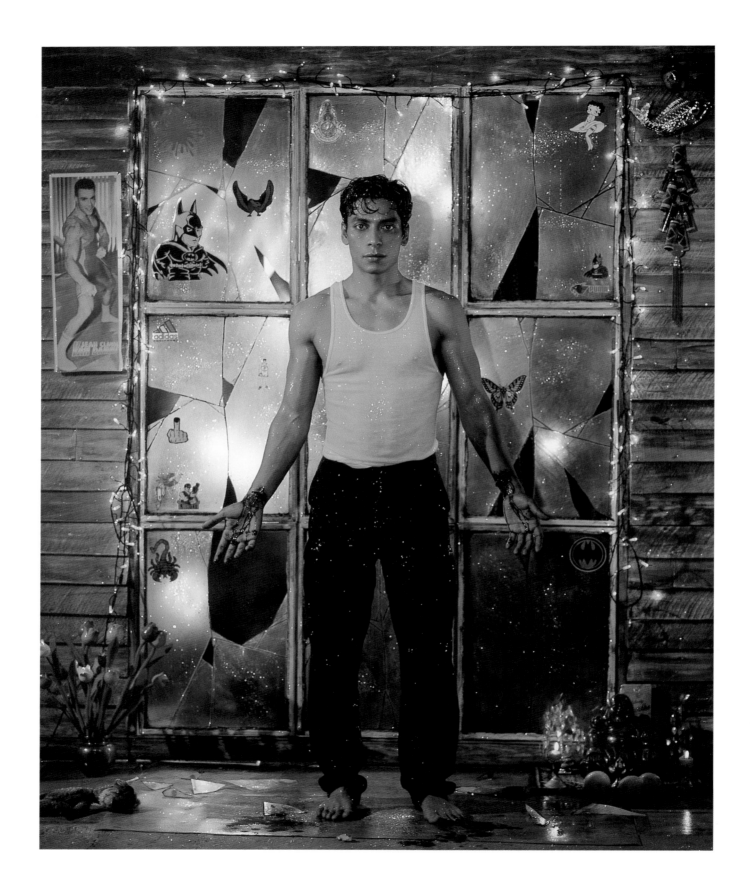

Le Garçon des Néons ~ Ken, 1998

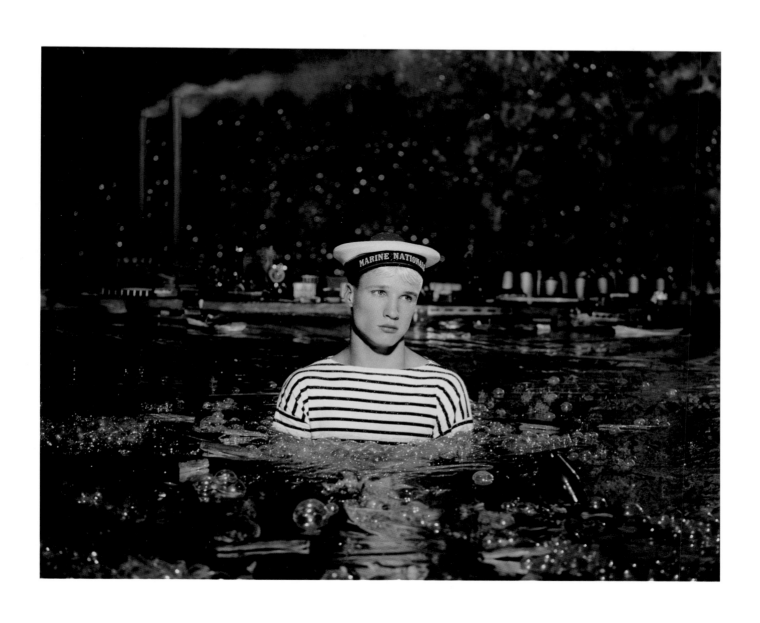

Dans Le Port du Havre ~ Frédéric Lenfant, 1998

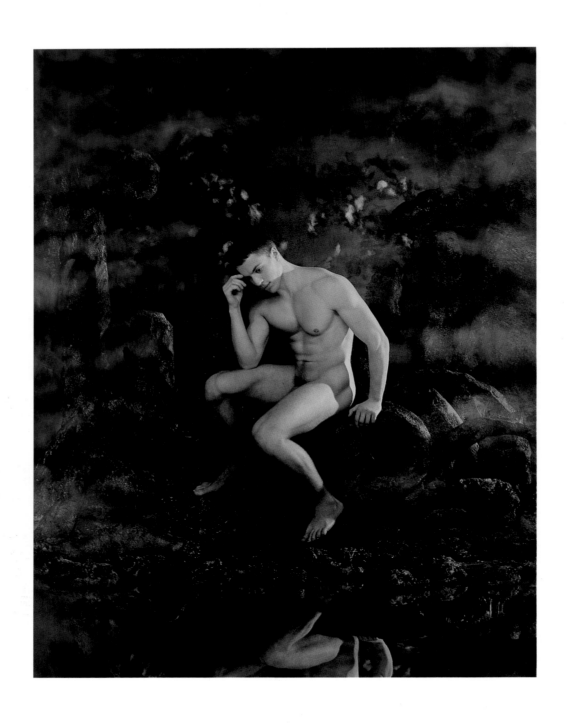

Le Jardin des Songes ~ Laurent Chemda, 1998

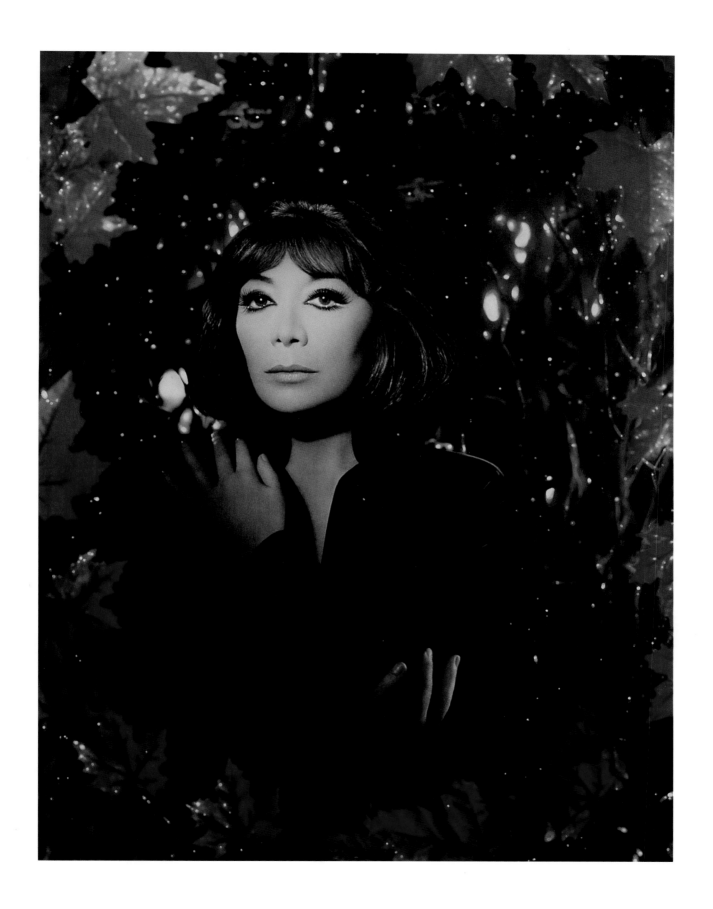

Un Soir d'Automne ~ Juliette Gréco, 1999

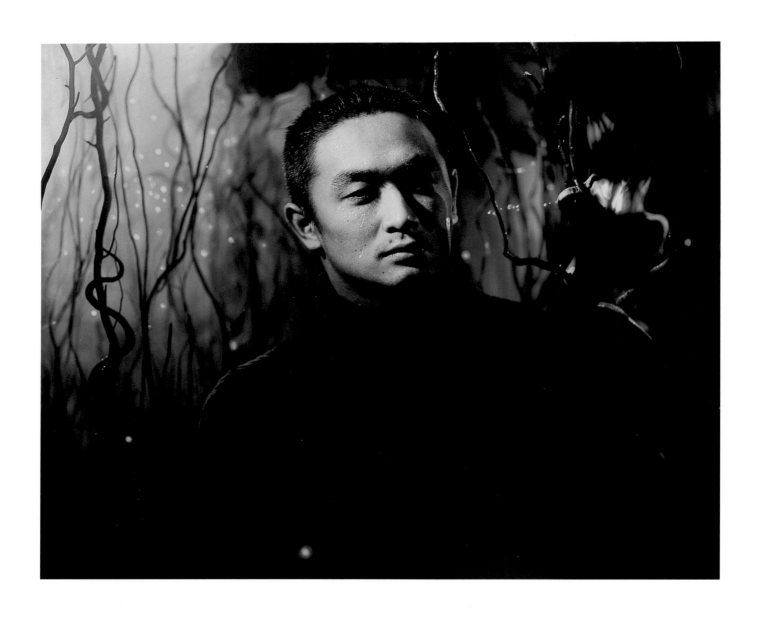

Tentation ~ Jiro Sakamoto, 1999

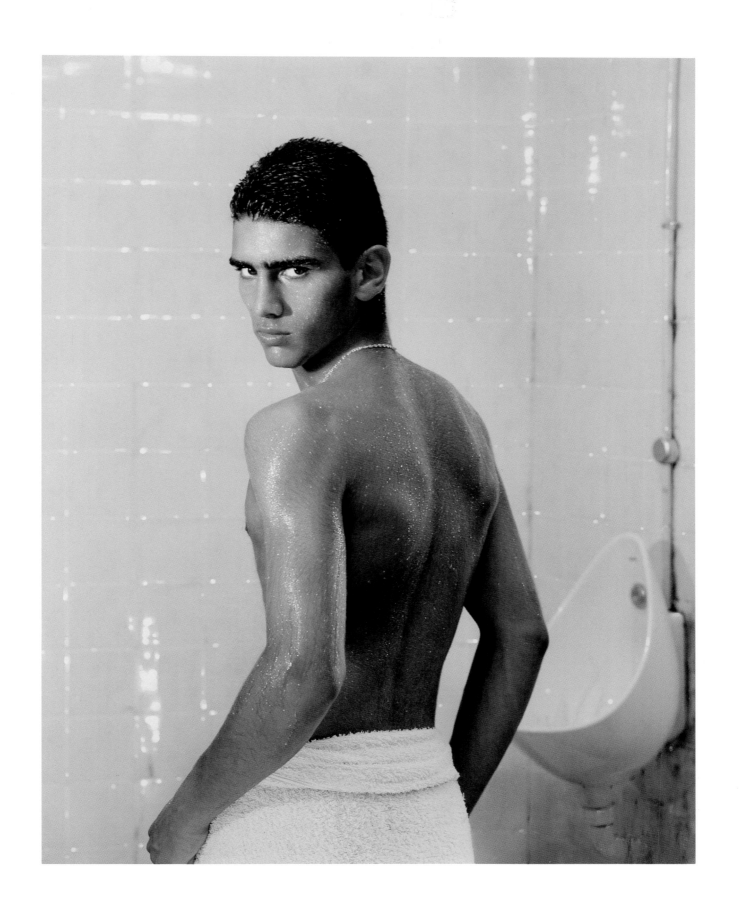

Saïd ~ Salim Kechiouche, 1999

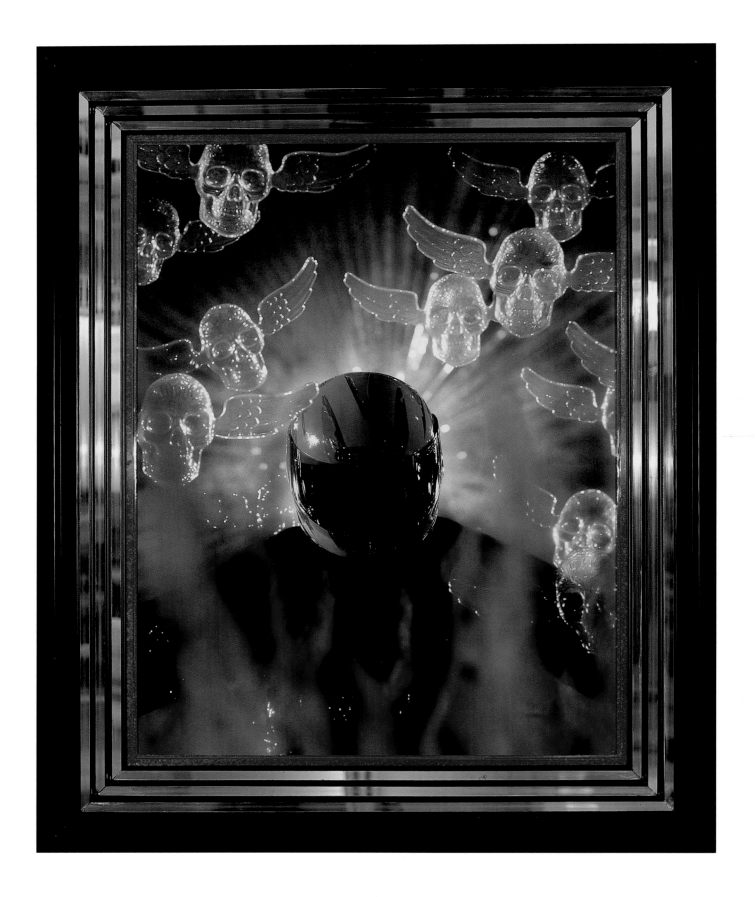

Autoportrait sans Visage ~ Pierre, 1999

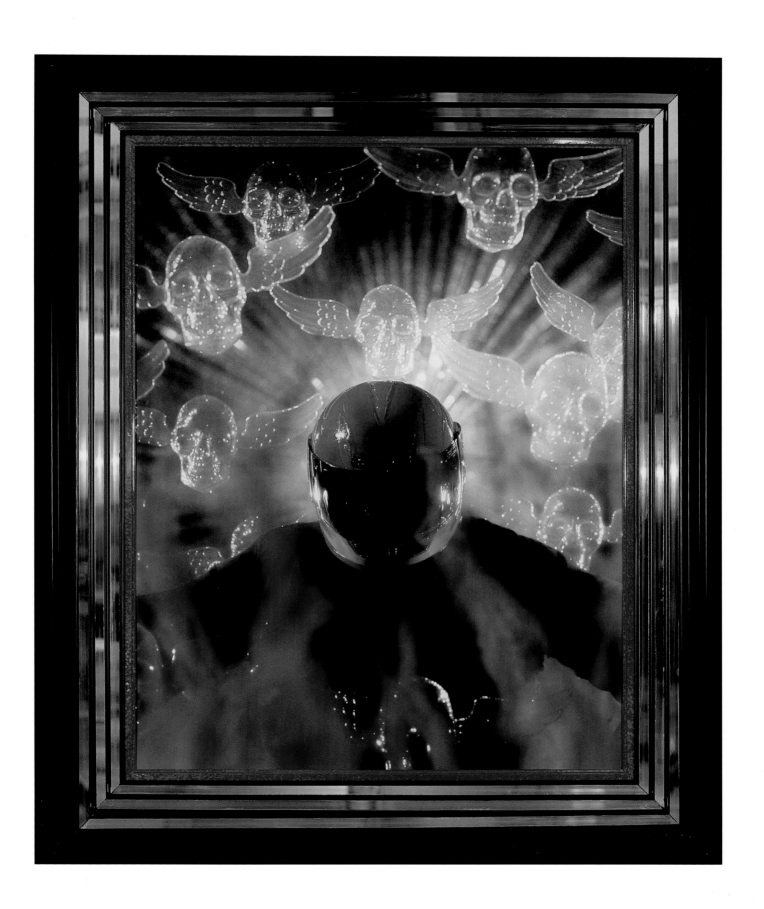

Autoportrait sans Visage ~ Gilles, 1999

CHECKLIST
All works are unique hand-painted photographs
and are listed chronologically

The Idiot, 1977
UNFRAMED 13¼ × 11″ (33.7 × 27.7 cm)
FRAMED 22¼ × 20″ (56.5 × 50.5 cm)
MODEL Iggy Pop
Private collection, Paris

Le Cow-Boy, 1978
UNFRAMED 16¼ × 11⅜″ (41.2 × 28.9 cm)
FRAMED 22½ × 17⅔″ (57.3 × 44.7 cm)
MODEL Victor
COSTUME Irié
Private collection

Yves Saint-Laurent, 1978
UNFRAMED 15 × 11″ (38.5 × 27.6 cm)
FRAMED 25⅛ × 20⅝″ (63.9 × 52.6 cm)
MODEL Yves Saint-Laurent
Private collection, Paris

Arja, 1979
UNFRAMED 11⅞ × 8¼″ (30 × 21 cm)
FRAMED 19¾ × 16⅛″ (50 × 41 cm)
MODEL Arja
COSTUME Adeline André
Created for the advertisement for the perfume
Sheramy
Private collection

Krootchey, 1980
2 × 12″ (30 × 30 cm)
MODEL Krootchey
Collection of M. Marc Lumbroso, Paris

Adam et Eve, 1981
6⅔ × 32⅔″ (93 × 83 cm)
MODELS Eva Ionesco and Kevin Luzac
HAIRDRESSER Bruno Decugis
Collection of Asher B. Edelman, New York

Silver Biker, 1982
UNFRAMED 12¼ × 9¼″ (31 × 23.5 cm)
FRAMED 20⅛ × 17¼″ (51.2 × 43.6 cm)
MODEL David Pontremoli
Courtesy of Galerie Jérôme de Noirmont, Paris

Dovanna, 1983
UNFRAMED 13 × 8⅔″ (32.7 × 22 cm)
FRAMED 31¼ × 27⅜″ (80.6 × 69.5 cm)
MODEL Dovanna
Courtesy of Galerie Jérôme de Noirmont, Paris

La Panne, 1983
5 × 19″ (37 × 48 cm)
MODELS Patrick Sarfati and Ruth Gallardo
Collection of Asher B. Edelman, New York

Le Jeune Pharaon, 1985
26 × 19″ (65 × 48 cm)
MODEL Hamid
Collection of Theodor von Oppersdorff, Zurich

Le Marin, 1985
21 × 15″ (52 × 37 cm)
MODEL Philippe Gaillon
Collection of Patrice Karr, Paris

Naufragé, 1985
UNFRAMED 11⅛ × 16⅔″ (28.3 × 42.3 cm)
FRAMED 21½ × 26¾″ (54.5 × 68 cm)
MODEL Hamid
Private collection

Pleureuse, 1986
UNFRAMED 21½ × 15⅜″ (54.6 × 39 cm)
FRAMED 33⅔ × 27¾″ (85.5 × 70.5 cm)
MODEL Claire Nebout
Private collection

Les Pistolets, 1987
UNFRAMED 21⅔ × 13¼″ (45.8 × 33.5 cm)
FRAMED 37¾ × 29″ (85.8 × 73.7 cm)
MODELS Pierre et Gilles
COSTUME Chachnil
Private collection, Paris

Saint Sébastien, 1987
UNFRAMED 21 × 14¾″ (53 × 37.5 cm)
FRAMED 27⅔ × 21⅔″ (69 × 54 cm)
MODEL Bouabdallah Benkamla
Collection Walter Haas, Zurich and Puerto Vallarta

Jésus Christ, 1988
UNFRAMED 17⅓ × 13¾″ (44 × 35 cm)
FRAMED 33½ × 29″ (85 × 73.5 cm)
MODEL Philippe Bialobos
Private collection

Neptune, 1988
UNFRAMED 20 × 15⅓″ (50.5 × 39 cm)
FRAMED 27⅔ × 32⅓″ (94 × 82 cm)
MODEL Karim
MAKE-UP ARTIST Andéas Bernhardt
Collection Walter Haas, Zurich and Puerto Vallarta

Sainte Blandine, 1988
UNFRAMED 20⅔ × 14½″ (52.5 × 36.8 cm)
FRAMED 43 × 36⅞″ (109 × 93.5 cm)
MODEL Arielle Dombasle
MAKE-UP ARTIST/HAIRDRESSER Andréas Bernhardt
Courtesy of Galerie Jérôme de Noirmont, Paris

Sarasvati, 1988
UNFRAMED 23⅔ × 18⅛″ (60 × 46 cm)
FRAMED 45⅓ × 40⅝″ (116 × 103 cm)
MODEL Ruth Gallardo
MAKE-UP ARTIST/HAIRDRESSER Andréas Bernhardt
Collection of Melissa Alonso, Paris

Sainte Barbe, 1989
UNFRAMED 21 × 14⅔″ (53.3 × 37.3 cm)
FRAMED 45⅔ × 36″ (116 × 91.5 cm)
MODEL Roussia
MAKE-UP ARTIST/HAIRDRESSER Andréas Bernhardt
COSTUME Kim Bowen
Private collection

Sainte Lydwine de Schiedam, 1989
UNFRAMED 20 × 14″ (50.5 × 35.5 cm)
FRAMED 40⅝ × 34⅔″ (103 × 88 cm)
MODEL Leslie Winner
MAKE-UP ARTIST/HAIRDRESSER Andréas Bernhardt
COSTUME Kim Bowen
Collection of the artists, Paris

Saint Martin, 1989
UNFRAMED 35¼ × 24⅔″ (89.5 × 62.5 cm)
FRAMED 58½ × 48″ (148.5 × 121.5 cm)
MODELS Marc Almond and Karim Boualam
MAKE-UP ARTIST/HAIRDRESSER Tony Allen
Collection of the artists, Paris

Méduse, 1990
UNFRAMED 32 × 23⅔″ (81 × 60 cm)
FRAMED 49 × 40⅝″ (124.5 × 103.5 cm)
MODEL Zuleika
MAKE-UP ARTIST/HAIRDRESSER Tony Allen
COSTUME Adeline André
Private collection, Zurich

Le Petit Communiste, 1990
49⅔ × 41″ (126 × 104 cm)
MODEL Christophe
MAKE-UP ARTIST/HAIRDRESSER Tony Allen
Collection of Pierre Nouvion, Monaco

Le Purgatoire, 1990
50⅛ × 39⅜″ (128 × 100 cm)
MODEL Marie-France
MAKE-UP ARTIST/HAIRDRESSER Tony Allen
Private collection

Saint Martin de Porres, 1990
51 × 40⅝″ (127 × 103 cm)
MODEL Carlos
Collection of Laura Willits Evans, New York

Le Petit Chinois, 1991
UNFRAMED 35 × 24¼″ (88.5 × 61.5 cm)
FRAMED 57⅔ × 47⅜″ (146.5 × 120.5 cm)
MODEL Tomah
COSTUME Tomah
Courtesy of Galerie Jérôme de Noirmont, Paris

La Reine Blanche, 1991
UNFRAMED 37 × 26″ (94 × 66 cm)
FRAMED 49⅜ × 38⅜″ (125.5 × 97.5 cm)
MODEL Catherine Deneuve
HAIRDRESSER Christophe Carita
Created for the poster of the film La Reine Blanche
Private collection

Saint Etienne, 1991
UNFRAMED 32⅔ × 30″ (83 × 75.8 cm)
FRAMED 54¾ × 45⅓″ (139 × 115 cm)
MODEL Hamid
Courtesy of Galerie Jérôme de Noirmont, Paris

Eliane Pine Caringhton, 1992
44⅔ × 35″ (111 × 87 cm)
MODEL Elian
MAKE-UP ARTIST/HAIRDRESSER Marc Lopez
COSTUME Tomah, Adeline André
Collection Dieter Rauh, Germany

MODEL Soraya
COSTUME Tomah
Collection of the artists, Paris

Le Petit Mendiant, 1992
49¼ × 42⅛″ (125 × 107 cm)
MODEL Tomah
COSTUME Tomah
Collection Douglas B. Andrews, San Venanzo, Italy

Au bout du Fusil, 1993
UNFRAMED 49¼ × 38⅜″ (125 × 97.5 cm)
FRAMED 54 × 43″ (137 × 109.2 cm)
MODEL Tomah
Collection Tomah Pantalacci, Paris

Nina Hagen, 1993
UNFRAMED 28¾ × 28¾″ (73 × 73 cm)
FRAMED 37⅜ × 37⅜″ (95 × 95 cm)
MODEL Nina Hagen
MAKE-UP ARTIST Topolino
HAIRDRESSER Marc Lopez
COSTUME Lola, Tomah
Created for the cover sleeve of
Nina Hagen's album *Revolution Ballroom*
Private collection, Paris

Elvis My Love, 1994
28 × 46⅔″ (71 × 118.5 cm)
MODEL Stavros
MAKE-UP ARTIST/HAIRDRESSER/COSTUME Stravos
Collection of Marsha and Darrel Anderson,
Newport Beach, CA

Ice Lady, 1994
UNFRAMED 41⅛ × 33¼″ (104.5 × 84.5 cm)
FRAMED 50⅔ × 43″ (128.5 × 109 cm)
MODEL Sylvie Vartan
MAKE-UP ARTIST Topolino
HAIRDRESSER Gérald Porcher
COSTUME Tomah, Lola
Private collection, Paris

Joli Voyou, 1995
UNFRAMED 18⅛ × 14¼″ (46 × 36 cm)
FRAMED 27 × 22⅔″ (68.5 × 57.5 cm)
MODEL Eric
Private collection

Le Papillon Noir, 1995
UNFRAMED 42⅛ × 33¼″ (107 × 84.5 cm)
FRAMED 51¼ × 42½″ (130 × 108 cm)
MODEL Polly
MAKE-UP ARTIST Polly
COSTUME Tomah, Thierry Mugler
Private collection

Courtesy of Galerie Jérôme de Noirmont, Paris

Les Plaisirs de la Forêt, 1996
UNFRAMED 34½ × 26″ (87.5 × 66 cm)
FRAMED 42⅓ × 34¼″ (107.5 × 87 cm)
MODEL Jiro Sakamoto
Collection of the artists, Paris

Les Plaisirs de la Forêt, 1996
44½ × 39⅜″ (113 × 100 cm)
MODEL Johnny
Collection Walter Haas, Zurich and Puerto Vallarta

Les Plaisirs de la Forêt, 1996
UNFRAMED 39 × 31″ (99.3 × 78.8 cm)
FRAMED 46⅔ × 38⅔″ (118.5 × 98 cm)
MODEL Lola
MAKE-UP ARTIST/HAIRDRESSER/COSTUME Lola
Collection of the artists, Paris

Les Plaisirs de la Forêt, 1996
UNFRAMED 38¼ × 29⅛″ (97 × 74 cm)
FRAMED 46¼ × 37¼″ (117.5 × 94.5 cm)
MODEL Polly
MAKE-UP ARTIST Lola
COSTUME Tomah, Thierry Mugler, Bertrand
Maréchal
Private collection

Les Plaisirs de la Forêt, 1996
UNFRAMED 40⅞ × 31½″ (103.5 × 79.8 cm)
FRAMED 48⅛ × 39″ (122.2 × 98.8 cm)
MODELS Etienne Daho, Sarah Cracknell, Bob and Pete
COSTUME Tomah
MAKE-UP ARTIST/HAIRDRESSER Andréas Bernhardt
Created for the sleeve of St. Etienne/Etienne Daho
mini-LP *Réserection*
Courtesy of Galerie Jérôme de Noirmont, Paris

Créatures, 1997
UNFRAMED 38 × 49⅔″ (96 × 126 cm)
FRAMED 46½ × 58¼″ (118 × 148 cm)
MODELS Siouxsie Sioux and Budgie
MAKE-UP ARTIST/HAIRDRESSER Andréas Bernhardt
STYLIST/COSTUME Tomah
HEADDRESS Thierry Mugler
Created for the sleeve of the
Creatures' album *Anima Animus*
Collection Galerie Voss, Düsseldorf

La Rose et Le Couteau, 1998
UNFRAMED 18½ × 14½″ (46.8 × 36.8 cm)
FRAMED 27 × 23″ (68.5 × 58.5 cm)
MODEL Tony
Private Collection, Minneapolis

Le Jardin des Songes, 1998
UNFRAMED 49½ × 38⅓″ (125.7 × 97.3 cm)
FRAMED 55¾ × 44⅔″ (141.7 × 113.4 cm)
MODEL Laurent Chemda
Courtesy of Galerie Jérôme de Noirmont, Paris

Autoportrait sans Visage, 1999
UNFRAMED 43⅔ × 34″ (111 × 86 cm)
FRAMED 52⅓ × 42½″ (133 × 108 cm)
MODEL Pierre
Collection of the artists, Paris

Autoportrait sans Visage, 1999
UNFRAMED 43⅔ × 34″ (111 × 86 cm)
FRAMED 52⅓ × 42½″ (133 × 108 cm)
MODEL Gilles
Collection of the artists, Paris

Saïd, 1999
UNFRAMED 34⅔ × 27⅓″ (88 × 69.5 cm)
FRAMED 42½ × 35¼″ (108 × 89.5 cm)
MODEL Salim Kechiouche
Created for the François Ozon movie *Les Amants
Criminels*
Collection of the artists, Paris

Un Soir d'Automne, 1999
UNFRAMED 34½ × 25⅓″ (87.8 × 64.4 cm)
FRAMED 43 × 34¾″ (108.9 × 88.4 cm)
MODEL Juliette Gréco
MAKE-UP ARTIST Pierre-François Carrasco
HAIRDRESSER Andréas Bernhardt
created for *Libération* daily newspaper
Courtesy of Galerie Jérôme de Noirmont, Paris

Tentation, 1999
UNFRAMED 22⅔ × 27½″ (57.5 × 70 cm)
FRAMED 34¾ × 40″ (88.2 × 101.2 cm)
MODEL Jiro Sakamoto
Courtesy of Galerie Jérôme de Noirmont, Paris

PERSONAL EXHIBITIONS

1983 Galerie Texbraun, Paris, *Pierre et Gilles*, November 15 – December 17

1985 The Art Ginza Space, Tokyo, *Pierre et Gilles*, April 2–18 (catalogue)

Galerie Saluces Art Contemporain, Avignon, *Pierre et Gilles*, May 24 – June 29

1986 Galerie des Arènes, Nîmes, *Pierre et Gilles – Naufrage*, March 25 – April 13 (catalogue)

Galerie Samia Saouma, Paris, *Naufrage*, November 4 – December 6

1988 Galerie Samia Saouma, Paris, *Les Saints*, November 24 – December 24

1990 Parco Par II de Shibuya, Tokyo, *Pierre et Gilles*, January 17 – February 12; Osaka, July 3–28

Hirschl and Adler Modern, New York, *Pierre et Gilles*, December 6 – January 8, 1991 (catalogue)

1992 Raab Galerie, Berlin, *Pierre et Gilles*, June 10–30

Russisches Museum, Diaghilev Center of Modern Art, St. Petersburg, *Pierre et Gilles*, July 10–31

Raab Galerie, London, *Pierre et Gilles*, September 2 – October 3

1993 Raab Gallery, London, *Absolut Peep-Show*

Galerie du Salon, DRAC des Pays de la Loire, Nantes

Galerie Samia Saouma, Paris, *Pierre et Gilles*, March 13 – April 30

Galleria Il Ponte, Rome, *Pierre et Gilles* (catalogue)

1994 Chapelle du Méjan, Rencontres Internationales de la Photographie, Arles, *Pierre et Gilles*, July 5 – August 15 (catalogue)

Le Case d'Arte, Milan, *Pierre et Gilles*, October 26 – November 29

1995 Roselyn Oxley9 Gallery, Sydney, February 8 – March 4; Australian Centre for Contemporary Art, Melbourne, March 10 – April 23; Wellington City Art Gallery, Wellington, April 28 – May 25; Auckland City Art Gallery, Auckland, June 30 – October 9: *Pierre et Gilles* (touring exhibition; catalogue)

Shiseido Gallery Ginza Art Space, Tokyo, *Annual '95*, June 20 – July 30 (catalogue)

1996 Galerie Max Hetzler, Berlin, *Les Plaisirs de la Forêt – Jolis Voyous*, June 1 – July 13

ACC Galerie, Weimar, *Pierre et Gilles*, July 20 – September 1 (catalogue)

Maison Européenne de la Photographie, Paris, *Pierre et Gilles, Vingt ans d'Amour (1976–1996)*, November 27 – January 26, 1997 (catalogue)

1997 Fotomuseum, Munich, *Die Welt von Pierre et Gilles*, May 29 – August 15

Gallery of Modern Art, Glasgow, *Pierre & Gilles – Grit and Glitter*, October 11 – November 9 (catalogue)

1998 Museo de Bellas Artes de València, Valencia, *Pierre et Gilles*, June 2 – July 29 (catalogue)

Shiseido Gallery Ginza Art Space, Tokyo, *Pierre et Gilles, Mémoire de Voyage*, exhibition organized for the Year of France in Japan, September 16 – October 18 (catalogue)

Galerie Jérôme de Noirmont, Paris, *Pierre et Gilles – Douce Violence*, December 4 – January 30, 1999 (catalogue)

1999 Turun Taidemuseo, Turku, *Pierre et Gilles*, November 14, 1999 – February 27, 2000 (catalogue)

2000 New Museum of Contemporary Art, New York, *Pierre et Gilles*, September 15, 2000 – January 21, 2001 (touring exhibition; catalogue)

GROUP EXHIBITIONS

1982 Galerie Viviane Esders, Paris, December

1984 ARC, Musée d'Art Moderne de la Ville de Paris, *Ateliers 84*, March 21 – April 29 (catalogue)

Galerie Texbraun, Paris, *La Photographie, la Mode*, March (catalogue)

1986 Galerie de Paris, March

Musée d'Art Contemporain, Montréal, *La Magie de l'Image*, June 1 – August 31 (catalogue)

1987 Palais des Beaux-Arts, Charleroi, *L'exotisme au quotidien*, February 7 – April 5 (catalogue)

Annina Nosei Gallery, New York

1988 Stills Gallery, Edinburgh, *Behold the man: The male nude in photography* (catalogue)

Musée de Botanique, Brussels, *Dis-moi qui est la plus belle*, February 12 – March 27 (catalogue)

Studio 43, Paris, *Écran total*, May 5

Universita Gabriele d'Annunzio, Pescara, *Dannunziana – Gabriele d'Annunzio nelle immagini europee contemporanae*, July 9 – August 31 (catalogue)

City Hall of the 16th arrondissement, Paris, *Itinéraire à travers la collection de Paris Audiovisuel*, November 4–26 (catalogue)

1989 Salzburg Festival

Pinacoteca Communale, Ravenna

Musée de Botanique, Brussels, *Le Choix de sens*, March 15 – May 7 (catalogue)

Kunstverein, Hamburg, *Das Porträt in der zeitgenössischen Photographie* (catalogue)

Fondation Cartier pour l'Art Contemporain, Jouÿ-en-Josas, *Nos années 80*, June 16 – November 5 (catalogue)

1990 Fundacão Gulbenkian, Lisbon, *A Fotografia actual em França* (catalogue)

1991 ICP, New York, February 1 – April 7; Mexico Museum of Modern Art, Mexico; Museum of Contemporary Art, New Orleans; Museum of Amsterdam, Amsterdam; Museum of Rotterdam, Rotterdam (catalogue); Kawasaki City Museum, Kawasaki, March 6 – March 29, 1992: *Contemporary French Photography en Liberté*, (touring exhibition)

Pence Gallery, Santa-Monica, *Consorts*, July 13 – August 24

Musée Saint-Pierre, Biennale de Lyon, Lyon, *L'Amour de l'art*, October 13 – November 3 (catalogue)

1992 Chapelle Saint-Julien, FRAC des Pays de la Loire, Laval, *Les images du plaisir*, July 3 – August 29 (catalogue)

A/B Galeries, Paris, *Illusions et Travestissements*, October 17 – December 20

Markthalle Moderne Kunst, Stuttgart, *Group Show*, October 23 – November 28

Galerie du Jour – agnès b., Paris, *Première photo*, November 8 – December 19 (catalogue)

Institut du Monde Arabe, Paris, *Images Métisses*, November 17 – January 5, 1993

1993 Groninger Museum, The Netherlands

Dooley Le Capellaine, New York, *Personal Jesus*

Galerie Gabrielle Maubrie, Paris, *Portraits d'artistes*, January 7 – March 6

Grand Palais, Collection Paris Audiovisuel, Paris, *Découvertes 93*, February 3–8 (catalogue)

Museum of Contemporary Art, Sydney, *Wit's End*, February 16 – May 23 (catalogue)

FAE, Musée d'Art Contemporain, Pully-Lausanne, *A la découverte . . . de collections romandes I*, February 19 – June 27 (catalogue)

Frankfurt, *Prospect 93*, March 20 – May 23 (catalogue)

Château de Villeneuve, Fondation Emile Hugues, Vence, *Histoires de voir*, April 4 – June 12 (catalogue)

Institut Français d'Ecosse, Edinburgh, June 4 – July 17 (catalogue); Zone and Central Station, Newcastle upon Tyne, September 4 – October 23 (catalogue), *Public/Private – secrets must circulate*, (touring exhibition)

Neue Galerie am Landesmuseum Joanneum, Forum Stadtpark, Graz, *Krieg*, Österreichische Triennale zur Fotografie 93, September 17 – October 31 (catalogue)

KunstHaus Wien, Vienna, *Diskurse der Bilder, Photokünstlerische Reprisen kunsthistorischer Werke*, November 26 – January 10, 1994 (catalogue)

94 Institut Français, Madrid, curated by the FRAC Aquitaine, *Le Corps en scène* (catalogue)

Ars Lux, Italy

Institut Français, Stuttgart

Rencontres Internationales de la Photographie, Arles, *Lunn Ltd.*, July 7–13

The Shoto Museum of Art, Tokyo, August 3 – September 18; Kariya City Museum, Aichi, September 23 – October 23; Municipal Museum of Art, Onomichi, October 30 – November 23; Akita Departmental Museum, Hiroshima, November 29 – December 25: *L'art du portrait français aux XIXe et XXe siècles*, (touring exhibition; catalogue)

Musée des Beaux-Arts d'Agen and FRAC Aquitaine, Agen, *. . . ou les oiseaux selon Schopenhauer*, August 5 – October 3

Passage de Retz, Paris, *Art & Jeans, reliefs minimaux*, September 3–8 (catalogue)

Galerie du Jour – agnès b., Paris, *La ville et la modernité – la jeune fille dans la ville*, October 30 – December 10 (catalogue)

National Gallery of Canberra, Canberra, *don't leave me this way: Art in the age of AIDS*, November 12 – March 5, 1995 (catalogue)

Museo Nacional Centro de Arte Reina Sofia, Madrid, *Cocido y Crudo*, December 14 – March 6, 1995 (catalogue)

Musée des Beaux-Arts, Tourcoing, November 19 – January 30, 1995; Ancienne Douane, Strasbourg, March 4 – April 30, 1995; Musée Communal, Ixelles, May 19 – July 30, 1995: *Les Métamorphoses d'Orphée*, (touring exhibition; catalogue)

1995 Musée de la Mode, Espace Mode Méditerranée, Marseille, *Make Up – Topolino*, February 3 – April 2 (catalogue)

Centre Photographique d'Ile-de-France, Pontault-Combault, *Face à Face*, February 15 – March 26

Museo Arte Cont., L. Pecci, Prato, April–June

Le Case d'Arte, Milan, *Pierre et Gilles, Andreas Gursky, Vincenzo Castella, Noritoshi Hirakawa, Zoe Leonard, Paul Graham, Wolfgang Tillmans*, June–October (catalogue)

Regina Gallery, Moscow, *On Beauty*, curated by Dan Cameron, September 29 – November 15 (catalogue)

Haus der Kunst, Munich, *Der zweite Blick*, November 4 – December 3

Deutsches Hygiene Museum, Dresden

Centre Georges Pompidou, Paris, *Féminin/Masculin – Le sexe de l'art*, October 24 – February 12, 1996 (catalogue)

1996 Galleria Photology, Milan, *Colorealismo*, January 12 – March 2

Maison Européenne de la Photographie, Paris, *Inauguration de la Maison Européenne de la Photographie*, February 22 – March 31 (catalogue)

The New Museum of Contemporary Art, New York, *The Auction Preview Party*, April 26

Ecole régionale des Beaux-Arts, Galerie du Cloître, Rennes, *La Piste aux étoiles*, June 4 – July 6

Galerie in der Alten Post, Esslingen, *Helden*, September 24 – October 9

Helmhaus, Zürich, *Paar Mal Paar*, August 17 – September 29 (catalogue)

Château de Val-Fréneuse, Sotteville-sous-le-Val, curated by the FRAC Haute-Normandie, *Les contes de fée se terminent bien*, September 15 – January 15, 1997 (catalogue)

1997 Centre d'Art Contemporain, Geneva, *La Revanche de Véronique*, Collection Marion Lambert

Kunstverein Eislingen/Fils, *Queer*

Koldo Mitxelena Kulturunea, Donostia, *Le Visage Voilé – Travestissements et Identité dans l'Art* (catalogue)

Akademie der Künste – Schwules Museum, Berlin, *100 Jahre Schwulenbewegung*

VII Biennale Internazionale di Fotographia, Palazzo Bricherasio, Turin, *Romantica – Immagini del Cuore e della Colpa* (catalogue)

1998 Tous les Dragons de Notre Vie, Paris, *Pour un objet-dard Dildo Show*, June 12–21

Fonds Régional d'Art Contemporain Nord-Pas de Calais, Dunkerque, *Un Monde Merveilleux Kitsch et Art Contemporain*, June 16 – September 12 (catalogue)

Passage de Retz, Paris, *Fétiches et Fétichismes*, June 23 – September 5

Galerie Jérôme de Noirmont, Paris, at FIAC, Paris, *En tout état de corps*, October 7–12

1999 PAC – Padiglione d'Arte Contemporanea, Milan, *Rosso Vivo – Mutazione, Trasfigurazione, e sangue nell'Arte Contemporanea*, January 21 – March 21 (catalogue)

Musée de la Vie Romantique, Paris, *Hommage à Jean-Marais – Héros Romantique*, May 27 – October 1 (catalogue)

Kunstmuseum Bern, Berne, *Missing Link: Menschen-Bilder in der Fotografie*, September 3 – November 7 (catalogue)

Geementemuseum, Helmond, *The Power of Beauty*, October 3 – January 9, 2000 (catalogue)

2000 Galleria d'Arte Moderna, Bologna, *Appearance*, January 27 – March 12 (catalogue)

Palais des Papes, Avignon, *La Beauté in Fabula*, May 27 – October 1 (catalogue)

Passage de Retz, Paris, *Narcisse Blessé*, June 20 – September 2 (catalogue)

First published 2000 by Merrell Publishers Limited
with the New Museum of Contemporary Art on the
occasion of the exhibition *Pierre et Gilles*, organized by
Dan Cameron

New Museum of Contemporary Art, New York,
September 15, 2000 – January 21, 2001

Yerba Buena Center for the Arts,
San Francisco, California,
February 10 – May 6, 2001

Pierre et Gilles is made possible by a generous grant from
Etants données, The French-American Fund for
Contemporary Art.

This publication is made possible by the Penny
McCall Publications Fund at the New Museum.
Donors to the Penny McCall Publications Fund are
James C.A. and Stephania McClennen, Jennifer
McSweeney, Arthur and Carol Goldberg, Dorothy
O. Mills, and the Mills Family Fund.

Catalog records for this book are available from the
Library of Congress and the British Library

ISBN 1 85894 113 X (hardback)
ISBN 1 85894 114 8 (paperback)

Designer: Matthew Hervey
Editor: Julian Honer
Printed and bound in Italy

Produced by Merrell Publishers Limited
42 Southwark Street, London SE1 1UN
www.merrellpublishers.com

Distributed in the USA and Canada by Rizzoli
International Publications, Inc. through St. Martin's
Press, 175 Fifth Avenue, New York, NY 10010

Photographs copyright © Pierre et Gilles
Courtesy Galerie Jérôme de Noirmont, Paris

FRONT JACKET/COVER *Les Plaisirs de la Forêt ~ Étienne
Daho, Sarah Cracknell, Bob and Pete*, 1996
BACK JACKET/COVER *Le Papillon Noir ~ Polly*, 1995
PAGE 1 *Les Plaisirs de la Forêt ~ Étienne Daho, Sarah
Cracknell, Bob and Pete*, 1996
PAGE 2 *Autoportrait à la Cigarette ~ Pierre*, 1999 (detail)
PAGE 3 *Autoportrait à la Cigarette ~ Gilles*, 1999 (detail)
PAGE 6 *Radha ~ Lisa Marie*, 2000 (detail)
PAGE 8 *Dans Le Port du Havre ~ Frédéric Lenfant*, 1998 (detail)
PAGE 10 *The Hole ~ Léo*, 2000 (detail)
PAGE 12 *La Beauté et la Mort ~ Paul*, 1999 (detail)